SO-BSE-599

The Canon Camera Handbook

The Canon Camera Handbook

BY THE EDITORS OF CURTIN & LONDON

Curtin & London, Inc.
Somerville, Massachusetts

Van Nostrand Reinhold Company
New York Cincinnati Toronto Melbourne

Printed in the United States of America

Published in 1981 by Curtin & London, Inc.
and Van Nostrand Reinhold Company
135 West 50th Street, New York, NY 10020, U.S.A.

Van Nostrand Reinhold Limited
1410 Birchmount Road
Scarborough, Ontario M1P 2E7, Canada

Van Nostrand Reinhold Pty. Ltd.
17 Queen Street
Mitcham, Victoria 3132, Australia

Interior and cover design: David Ford
Cover photograph: Courtesy of Canon U.S.A., Inc.
Production editor: Lisbeth Murray
Illustrations: Omnigraphics
Photo research: Lista Duren
Composition: P & M Typesetting, Inc.
Printing and binding: Kingsport Press
Covers: Phoenix Color Corp.

Product photographs appearing throughout book courtesy of Canon
U.S.A., Inc.

10 9 8 7 6 5 4 3 2

Library of Congress Cataloging in Publication Data
Main entry under title:

The Canon Camera handbook.

 Includes index.
 1. Canon camera. 2. Photography—Handbooks, manuals,
etc. I. Curtin & London, inc.
TR263.C3C36 1981 771.3′1 81-9711
ISBN 0-930764-32-3 AACR2

Contents

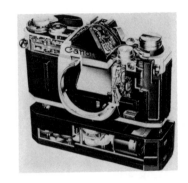

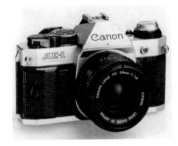

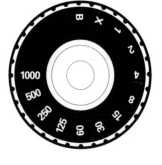

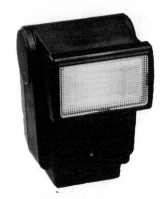

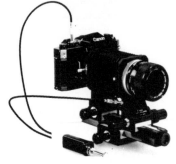

Preface

The introduction, a few short years ago, of the Canon's automatic 35mm single-lens reflex cameras has helped revolutionize photography. Their simplicity of operation and the quality of their results have made Canon cameras among the most popular 35mm SLR cameras in photography. These automatic cameras and others like them have contributed, along with the growing appreciation of photography as a fine art, to the recent explosion of interest in photography as a form of self expression.

This carry-along handbook is written and organized specifically for the Canon automatic camera user. It completely covers all Canon automatic SLR's, including the A-1, AE-1, AE-1 Program, AV-1, and F-1. It explains as simply as possible how to use your Canon camera's controls to get the exact results you want. Its highly visual approach with hundreds of line drawings and photographs and its organization with each two facing pages containing a single, complete topic, make your understanding of camera operations easier and yet comprehensive enough to be useful.

As a user of an automatic camera, you know (or soon will) that automatic cameras don't automatically give great or even good pictures. They simplify camera operation but you, the photographer, are still in control and your creative decisions affect the way the final image appears.

You will occasionally encounter situations when you will want to override your camera's automatic exposure system. At other times you will want to make creative decisions about sharpness, whether to freeze or blur motion, or to have the background sharp or slightly out of focus. Finally, you will want to choose equipment such as film, lenses, and lens attachments, to give you additional control over your results.

These choices make the difference between dull and exceptional photographs. Understanding how to make these choices isn't difficult and once you know a few basic principles you have an almost infinite variety of possibilities to explore.

This book and others in the Automatic Camera Series provide a starting point and a firm foundation on which you can build your technique to get better and to enjoy your photography more.

1 Your Canon Automatic Camera

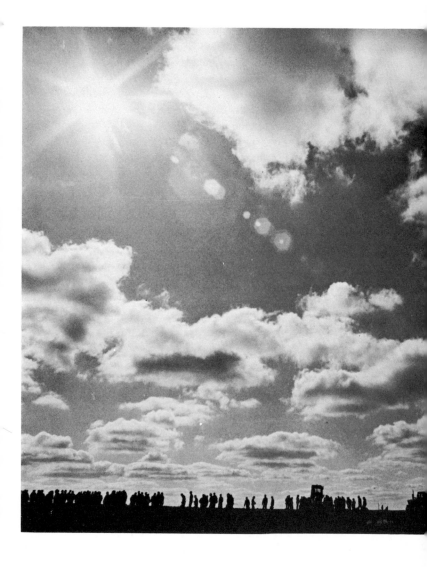

USDA Photo by Gordon Baer

Your Canon Automatic Camera

A Canon automatic 35mm single-lens reflex (SLR) camera is really a family of automatic components.

AUTOMATIC EXPOSURE CONTROL

The exposure—the amount of light that reaches the film—determines how light or dark the resulting photograph will be. When the shutter opens, light (reflected from the subject and focused by the lens) strikes the light-sensitive film inside the camera. If too much light strikes the film, the photograph will be overexposed—washed out and faded looking. Too little light produces an underexposed photograph—dark and lacking in detail, especially in shadow areas.

The amount of light that exposes the film is controlled by adjusting either the aperture (the size of the opening through which light enters the camera) or the shutter speed (the length of time that light is allowed to enter). With automatic exposure control, the camera makes one or both of these adjustments for you.

With your camera set for manual exposure control, *you* adjust the aperture and shutter speed according to a light reading made by the camera's built-in light meter or by a separate hand-held meter. Many photographers prefer a camera that has the option of using either the automatic or the manual exposure controls. Although you may not know how to use the manual settings effectively at first, you will eventually appreciate the benefits.

AUTOMATIC FLASH

Canon electronic flash units have a sensor that regulates the duration of the flash to assure a good exposure within a preset range of distances from the camera. Dedicated flash units have special functions when used with specific cameras: they can set the camera's shutter to the correct speed for flash, indicate in the camera's viewfinder when the flash is ready to fire, and confirm correct flash exposure.

MOTORIZED FILM ADVANCE

Manually advancing the film to the next frame can be a disadvantage when you are shooting in a fast-changing situation, because you can miss a shot while you are taking the time to wind the film forward. Motor drive units or power winders automatically advance the film each time you press the shutter button so that the camera is always ready to take the next picture or they can advance it continuously for rapid sequence shooting.

Automatic
Electronic
Flash

Automatic
Exposure
Control

Motorized Film Advance

The Canon A-1

The A-1 offers total exposure flexibility: six exposure modes, compact size and many advanced features. The A-1 accepts the Data Back A, Power Winder A or A2, and Motor Drive MA (p.16) as well as dedicated flash units (pp. 128-131).

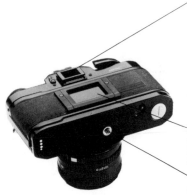

Eyepiece accepts dioptric adjustment lenses (for nearsightedness or farsightedness), eyecup (to block stray light from the eye), angle finder and magnifier (p.143). To prevent light from entering the eyepiece and affecting automatic exposure, a built-in eyepiece shutter can be closed when you are shooting without viewing through the finder.

Memo holder frame holds film box tab as reminder of film type. Detachable back cover interchanges with accessory Data Back A.

Tripod socket accepts standard tripod mounting screw.

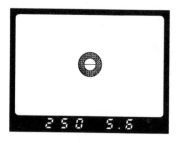

The A-1 viewfinder displays all information in a 7-digit LED (light-emitting diode) display: shutter speed, aperture, when the flash is charged and ready to fire, when the camera is in manual mode, and other exposure and operational signals.

Stop-down lever closes the lens to the preset aperture for depth-of-field preview or stopped-down metering.

Exposure memory switch holds a reading constant, for example, to meter a subject up close, then step back for the exposure.

AE mode selector and **AT dial** select the desired automatic exposure mode: shutter-priority (you select the shutter speed and the camera sets the aperture); aperture-priority (you select the aperture and the camera sets the shutter speed); programmed (the camera sets both shutter speed and aperture). Other exposure modes include flash automatic (camera sets shutter speed and aperture when used with Canon dedicated flash unit); stopped-down automatic (aperture-priority automatic exposure with nonautomatic lenses or accessories); manual (you set both aperture and shutter speed with suggested correct exposure displayed in viewfinder).

Self-timer/Battery check LED signal blinks during 2–10 sec self-timer cycle and during battery check.

Multiple exposure lever permits two or more exposures to be made on the same film frame.

Shutter release button activates the meter circuit and viewfinder LED display with slight finger pressure. Further pressure triggers shutter. Threaded for accessory cable release.

AT dial window displays P for programmed, the preset aperture or shutter speed (from 1/1000 to 30 sec, plus B for longer exposures).

Frame counter, additive type, resets when back cover is opened.

Flash hot shoe supports shoe-mount electronic flash units and provides cordless electrical connection with most units.

Flash terminal has PC outlet for flash units that do not connect with the shutter via the hot shoe.

Exposure compensation dial overrides automatic system to increase or decrease exposure up to 2 stops in 1/3 stop increments.

ASA scale can be set for film speeds from ASA 6-12,800 (DIN 9-42).

The Canon AE-1

The AE-1 combination of automatic features and reasonable cost has made it a best-seller. The camera offers compact size, shutter-priority automatic exposure, plus use of all A Series accessories (p.16) except for motor drive. Any Canon dedicated flash unit (pp.128-131) will set the camera's shutter speed and aperture.

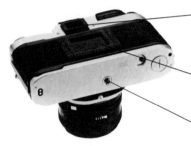

Eyepiece accepts dioptric adjustment lenses (for nearsightedness or farsightedness), eyecup (to block stray light from the eye), angle finder and magnifier (p.143).

Memo holder frame holds film box tab as reminder of film type. Detachable back cover interchanges with accessory Data Back A.

Tripod socket accepts standard tripod mounting screw.

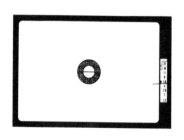

The AE-1 viewfinder displays the aperture scale and a needle pointer to show the aperture selected by the camera's automatic exposure system. LED signals indicate when the camera is set for manual exposure, warn of underexposure or overexposure, and give other operational information.

Stop-down lever closes the lens to the preset aperture for depth-of-field preview or stopped-down metering.

Backlight control increases exposure 1½ stops for better exposure of a subject against a very bright background.

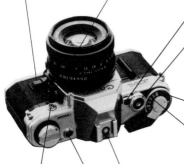

Self-timer LED signal blinks during 10 sec self-timer cycle.

Shutter release button activates the meter circuit and viewfinder display with slight finger pressure. Further pressure triggers shutter. Threaded for accessory cable release.

ASA scale can be set for film speeds from ASA 25-3200 (DIN 15-36).

Shutter speed dial sets electronically controlled shutter speed from 1/1000 to 2 sec, plus B for longer exposures. In shutter-priority automatic operation, you select the shutter speed and the camera sets the correct aperture for normal exposure. In manual operation, you select both shutter speed and aperture yourself with suggested correct aperture displayed in viewfinder.

Flash hot shoe supports shoe-mount electronic flash units and provides cordless electrical connection with most units.

Flash terminal has PC outlet for flash units that do not connect with the shutter via the hot shoe.

Battery check indicates in viewfinder whether the battery has sufficient power for operation.

The Canon AE-1 Program

The AE-1 Program offers the shutter-priority automatic operation of the AE-1 plus programmed automatic mode and other features similar to the A-1. It accepts all A Series accessories (p. 16) including motor drive. Any Canon dedicated flash unit (pp. 128-131) will set the camera's shutter speed and aperture. Speedlite 188A activates a signal in the viewfinder that shows when the unit is fully charged and then flashes to confirm proper exposure after firing.

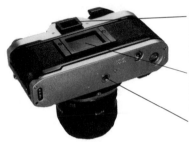

Eyepiece accepts dioptric adjustment lenses (for nearsightedness or farsightedness), eyecup (to block stray light from the eye), angle finder and magnifier (p.143).

Memo holder frame holds film box tab as reminder of film type. Detachable back cover interchanges with accessory Data Back A.

Tripod socket accepts standard tripod mounting screw.

The AE-1 Program viewfinder displays the aperture plus P for programmed mode, M for manual mode, and with Speedlite 188A, a flash ready/flash checking signal. A New Split rangefinder provides a brighter screen with split-image focusing that does not darken even with lenses that can cause problems with ordinary rangefinders. Other user-interchangeable viewing screens are available.

Stop-down lever closes the lens to the preset aperture for depth-of-field preview or stopped-down metering.

AE lock switch holds a reading constant, for example, to meter a subject up close, then step back for the exposure.

Flash terminal has PC outlet for flash units that do not connect with the shutter via the hot shoe.

Frame counter, additive type, resets when back cover is opened. Counts backwards as film is rewound.

Self timer emits audible signal during 10 sec self-timer cycle.

Shutter release button has convenient finger rest. Slight finger pressure on the button activates the meter circuit and viewfinder LED display. Further pressure triggers shutter. Threaded for accessory cable release.

Shutter speed dial sets electronically controlled shutter speed from 1/1000 to 2 sec, plus B for longer exposures. In "Program" position, the camera selects the most suitable shutter speed and aperture combination. In shutter-priority automatic operation, you select the shutter speed and the camera sets the correct aperture for normal exposure. In manual operation, you select both shutter speed and aperture yourself with suggested correct aperture displayed in the viewfinder.

Flash hot shoe supports shoe-mount electronic flash units and provides cordless electrical connection with most units.

Battery check emits audible signal to indicate whether the battery has sufficient power for operation.

ASA scale can be set for film speeds from ASA 12-3200 (DIN 12-36).

The Canon AV-1

The AV-1 is a compact camera, designed primarily for aperture-
priority automatic operation. The least expensive of Canon's
A Series cameras, it accepts the A Series power winders (p.16).
Any Canon dedicated flash unit (pp. 128-131) will set the camera's
shutter speed and aperture.

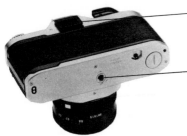

Eyepiece accepts dioptric adjustment
lenses (for nearsightedness or farsight-
edness), eyecup (to block stray light
from the eye), angle finder and magni-
fier (p.143).

Tripod socket accepts standard tripod
mounting screw.

*The AV-1 viewfinder is somewhat
similar to the AE-1 viewfinder.
A shutter speed scale is displayed
with a needle pointer to indicate
the speed selected by the auto-
matic exposure system. Also
displayed are underexposure and
overexposure warnings and other
operational information.*

Backlight control increases exposure 1½ stops for better exposure of a subject against a very bright background.

Self-timer LED signal blinks during 10 sec self-timer cycle.

Shutter release button activates the meter circuit and viewfinder display with slight finger pressure. Further pressure triggers shutter. Threaded for accessory cable release.

Frame counter, additive type, resets when back cover is opened.

Selector dial serves as control for most functions. "A" position sets camera to aperture-priority automatic exposure (you select the aperture and the camera chooses the shutter speed from 1/1000 – 2 sec); "A Self" (automatic operation with a self timer that delays exposure for 10 sec after you press the shutter release); "60" (1/60 sec for use with flash units other than the automatically functioning Canon Speedlites); and "B" (exposures longer than 2 sec). The camera does not have a fully manual mode in which you can set any shutter speed and aperture yourself.

Flash hot shoe supports shoe-mount electronic flash units and provides cordless electrical connection with most units.

Battery check indicates in viewfinder whether the battery has sufficient power for operation.

ASA dial can be set for film speeds from ASA 25-1600 (DIN 15-33).

The Canon F-1

The F-1, Canon's professional system camera, has a modular construction that makes it adaptable to just about any photographic situation. A manual, match-needle system produces the correct exposure by lining up a straight needle and a "lollipop" needle in the viewfinder. Automatic shutter-priority exposure is available by using the Servo EE Finder (p.17). Many accessories are available; see pp. 17-19.

Battery check indicates in the viewfinder whether the battery has sufficient power for operation.

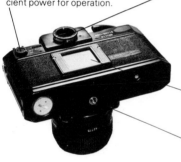

Eyepiece accepts dioptric adjustment lenses (for nearsightedness or farsightedness), eyecup (to block stray light from the eye), angle finder and magnifier (p.143). To prevent light from entering the eyepiece and affecting automatic exposure, a built-in eyepiece shutter can be closed when you are shooting without viewing through the finder.

Memo holder frame holds film box tab as reminder of film type. Detachable back cover interchanges with accessory Data Back F.

Tripod socket accepts standard tripod mounting screw.

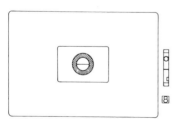

Visible in the viewfinder are the shutter speed, the needles used to set the correct exposure, over- and underexposure warning marks, and an index mark used for stopped-down metering and as a battery check. If you often photograph in dim light, accessory Finder Illuminator F makes these readouts easier to see.

Self timer lever lets you delay shutter release for about 10 sec after shutter button is pushed. Lever is also used during stopped-down metering.

Shutter release button has a surrounding rim that helps provide smoother release action.

Frame counter, additive type, resets when back cover is opened.

Shutter speed dial sets speeds from 1/2000 – 1 sec, plus B for longer exposures. Titanium foil shutter is extremely long wearing.

ASA scale can be set for film speeds from ASA 25-3200 (DIN 15-36).

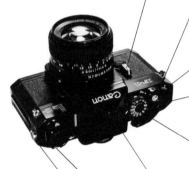

Interchangeable viewfinder. The standard pentaprism finder supplied with the camera is quickly interchangeable with other types of finders (p.17).

Flash shoe bracket accepts accessory flash coupler that supports shoe-mount electronic flash units and provides cordless electrical connection with most units.

Flash terminal has PC outlet for flash units that do not connect with the shutter via the accessory hot shoe. Threaded collar around the terminal makes possible both screw-in and plug-in flash cord attachment.

"A" Series Accessories

Cary Wasserman

Motorized Film Advance. With a motor drive unit or a power winder attached to the camera you can expose either 1 frame at a time or in rapid sequence at rates, depending on the unit, up to 5 frames per second.

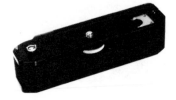

The Motor Drive MA is designed for the A-1 and AE-1 Program. One touch of your finger automatically exposes and advances the film and cocks the shutter, either a single frame at a time or at rates up to 5 frames per second.

Power Winder A attaches quickly to the bottom of any of the A Series cameras. The winder is activated by the camera's shutter release button which winds the film forward ready for the next exposure a single frame at a time or up to 2 frames per second. Power Winder A2 is similar, but offers the option of remote control firing when used with the A-1 or AE-1 Program.

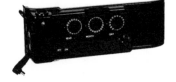

The Data Back A is quickly interchangeable with the A-1, AE-1, or AE-1 Program back. A built-in lamp automatically imprints the date or other numerical or alphabetical data onto the lower right corner of the frame during the exposure; a manual control on the back lets you imprint individual frames if you want to have data on ◀ only some.

F-1 Accessories

The Booster T Finder extends the metering range of the F-1 in low-light situations or where long bellows extensions reduce the amount of light reaching the camera's built-in meter. The Booster T's photocells make this finder extremely sensitive—capable of readings down to 15 sec at f/1.2 with ASA 100 film. A built-in lamp illuminates meter data and during long exposures a light blinks at 1-second intervals. The Booster T Finder has a shutter built into the eyepiece to prevent extraneous light from interfering with meter functions.

The Servo EE Finder converts the F-1 to fully automatic, shutter-priority operation. After you select the shutter speed you want, the EE's servo motor adjusts the diaphragm of the lens to the correct aperture. The motor preserves battery power by automatically switching off when the light is too low for the meter to read.

The Waist Level Finder consists of a folding hood with a flip-up 5X magnifier for critical focusing. It is useful in copying, macrophotography, or any other application where low-level or direct viewing is required. This finder shows an upright image, but one that is reversed left to right. Metering information does not appear.

The Speed Finder rotates for either eye-level or chest-level viewing and focusing, which makes it useful for sports photography, aerial photography, copying, and macrophotography. Since this finder permits full-frame viewing and focusing with the eye as far as 2.5 in (60 mm) from the rear of the eyepiece, it is useful when goggles or other eye-protecting devices are worn.

F-1 Accessories (cont.)

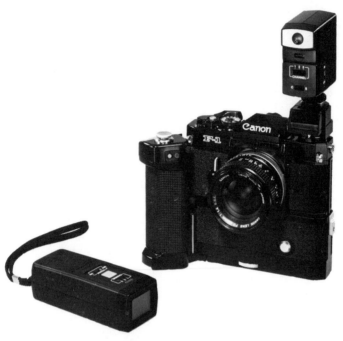

The Motor Drive MF is the basic
motor drive unit for the F-1
camera. The unit is capable of
winding the film, cocking the
shutter, and releasing the shutter a
single frame at a time or at speeds
up to 3.5 frames per second. It
consists of two parts: the motor
section, which attaches to the
bottom of the camera, and the grip
section (containing 10 AA penlight
batteries that power the unit),
which attaches to the right side of
the camera. (The Motor Drive
MF is shown here with an optional
Wireless Controller LC-1 in
place on top of the camera body;
the triggering device for the
controller is at left.)

The Motor Drive MD (not shown)
winds the film and cocks and
releases the shutter at speeds from
3 frames per second to 1 frame
at a time. It contains an intervalo-
meter which can be programmed
to shoot at rates from 3 fps to
1 frame per minute. The unit con-
sists of a motor section with a
pistol-type grip and a separate
battery case.

Interval Timer L (not shown)
enables the Motor Drive MF with
the F-1 camera to make unat-
tended exposures at intervals from
one shot every ½ second to one
every 3 minutes.

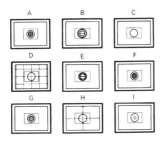

Focusing screens are readily interchangeable.

A Central microprism, matte/fresnel field. For general use.

B Split image, matte/fresnel field. For general use.

C Full matte with central area a fine matte. Recommended for use with long telephoto and super-telephoto lenses.

D Same as C with an added grid. For exact subject alignment.

E Split image with microprism, matte/fresnel field. For general use. Supplied with camera.

F Same as A but designed for lenses of f/2.8 or wider maximum aperture.

G Same as A but designed for lenses with maximum apertures from f/3.5 to f/5.6.

H Same as C with horizontal and vertical scales which cross at the center of the screen. For scientific or close-up work or in general photography.

I Matte/fresnel field with a double cross-hair reticle. For precise focusing at extremely high magnifications.

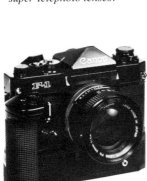

The Film Chamber 250 lets you make 250 exposures without reloading and is useful for motorized sports photography, unattended setups, or other work where you want uninterrupted shooting. It can be used with or without motor drive or power winder.

Power Winder F is a lightweight unit designed for the F-1; it exposes and advances film either a single frame at a time or as fast as 2 frames per second. Four alkaline penlight or NiCad batteries power the unit for more than 700 exposures, and when battery voltage is inadequate a red LED lights up and the winder stops. An audible tone signals the end of the roll of film.

Data Back F (not shown) replaces the regular film chamber back and by means of a built-in lamp imprints day, month, and year or other numerical and alphabetical information in the lower right-hand image area. Imprinting can be done automatically on each film frame or manually on only some. (See illustration of similar Data Back A on p. 16.)

A Basic Camera Outfit

The popularity of Canon automatic 35mm SLRs results not only from their small size and high quality, but also from their great versatility. By adding a few accessories, you can adapt your basic camera to a wide variety of situations.

The Camera. Canon automatic exposure cameras are available with various operating modes: aperture-priority, shutter-priority, programmed (totally automatic), and manual. Most have more than one mode, allowing you to select the most appropriate mode for a particular situation. (See pp. 42–43).

Tripod and Cable Release. Tripods, clamps—some small enough to carry in your pocket—and cable releases are used in low light or with long-focal-length lenses to eliminate blurring caused by camera movement. (See pp. 76–77.)

Film. Film in the 35mm format is widely available in many varieties. A negative film produces negatives that are then used to make prints. A reversal film is processed directly into slides. (See pp. 80–83.)

Batteries. Battery failure will result in the loss of some or all of your camera's functions. Always carry spares for the camera, flash, and power winder or motor drive.

Lens Hood. Besides protecting the lens from rain and snow, the lens hood (or lens shade) improves color saturation and contrast in your photographs by

eliminating the flare caused by stray light.

Lens Cleaning Materials. Always use special tissue and cleaning fluids to prevent damage to the sensitive lens surface. (See p. 25.)

Interchangeable Lenses. Your camera's versatility is greatly enhanced by its ability to use a variety of lenses. (See pp. 102–103.)

Filters and Lens Attachments. Screwed onto the front of the lens, filters can change contrast, balance colors, and achieve certain special effects. (See pp. 114–125.)

Electronic Flash. Electronic flash is a convenient way to add light to a scene. Canon flash units are automatic in operation. (See pp. 130–131.)

Power Winder. A power winder or motor drive unit that automatically advances the film every time you press the shutter release is useful for photographing sports and other rapidly changing scenes.

Camera Case. A camera case is invaluable for conveniently and safely transporting your camera and accessories. (See pp. 22–23.)

The Basic System

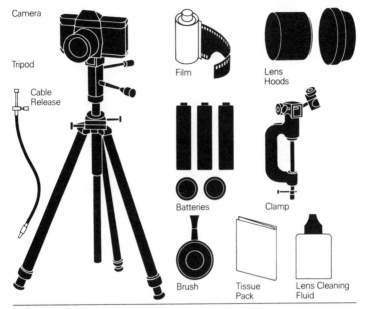

Camera

Tripod

Cable Release

Film

Lens Hoods

Batteries

Clamp

Brush

Tissue Pack

Lens Cleaning Fluid

Most Useful Accessories

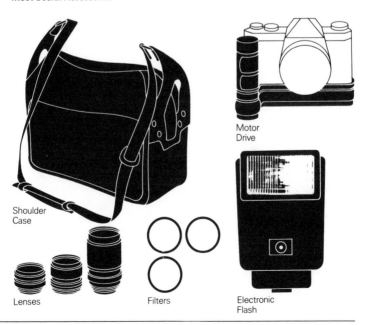

Shoulder Case

Lenses

Filters

Motor Drive

Electronic Flash

Carrying Your Equipment

Your camera, lenses, and accessories are delicate instruments that should be protected from bumps and dust. Although a comfortable neck strap is useful while you are actually photographing, you will also need additional carrying and protective gear for storing and transporting your equipment.

Individual Camera Case. *A case for an individual camera and lens is ideal for storage and travel, and provides extra protection when your camera is in a suitcase or gadget bag. With a two-piece eveready case, you can drop down the front of the case instead of removing it entirely when taking pictures.*

Outfit Case. *A rigid metal case is ideal for storing or shipping camera equipment; each item in the outfit is stored in its own cushioned compartment. Although cumbersome to carry, this is the strongest and safest case available.*

Gadget Bag. *Made of less rigid material such as leather or canvas, a gadget bag is considerably lighter and easier to carry than an outfit case but offers somewhat less protection.*

Special-Purpose Bag. *Special-purpose camera bags are designed to be used while hiking (like a backpack), boating (waterproof and floatable), or biking (strapped to the bike frame). Consult your dealer for available models.*

Lens Caps and Cases. *A lens cap protects the front element of the lens when it is on the camera. Off camera, a lens should be capped front and back to prevent scratches and placed in a protective case to absorb shocks. A body cap fits on a camera over the opening normally occupied by a lens and protects the interior of the camera if the lens is removed for an extended time.*

Filter Cases. *Filter surfaces need protection too. You can keep a glass filter in the individual plastic case it is packaged in when you buy it or if your filters are all the same size you can screw them together and then cap the two ends for protection.*

Neck Strap. *Choose a neck strap* ▶ *wide enough to support the weight of the camera comfortably around your neck. Be sure the clips lock securely and that the camera cannot work loose.*

Chest Strap. *A chest strap holds* ▶ *the camera securely against your chest to prevent it from bouncing when you hike or climb.*

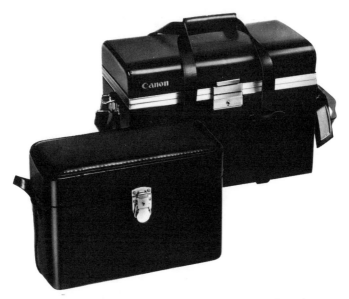

A case is a necessity if you want to protect your equipment from dust, moisture, and accidental damage. The Gadget Bag 4 (left) is a medium-sized hard case with an internal partition and pocket. It holds a camera plus accessories and has a shoulder strap for carrying. The Gadget Bag G-1 (right) is a larger hard case with an internal pocket and several partitions to hold an assortment of camera bodies, lenses, and other accessories. It has both a shoulder strap and luggage-type handles. Other soft and hard cases are available for an individual camera with lens, for a single lens, or for certain accessories like an interchangeable F-1 finder.

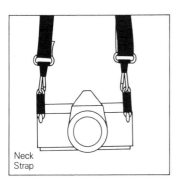

Neck Strap

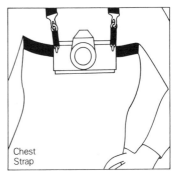

Chest Strap

Caring for Your Camera and Lens

CARE AND TROUBLESHOOTING

Batteries. Dead batteries will limit the operation of your automatic camera and sometimes cause total shutdown. Always carry spares, especially in cold weather when batteries are weakest. If batteries are weak (your camera may have a display that indicates battery strength), try gently rubbing the battery terminals with a pencil eraser.

Water. Excessive moisture can corrode the electrical circuitry of your automatic camera and lead to serious problems. Use a plastic bag to protect your camera from rain, heavy mist, and salt water spray. By cutting out holes for the lens and viewfinder and using rubber bands to seal around the edges, you can protect the camera without impairing your view. Immersion in water can result in irreparable damage to your camera. If it is immersed in salt water, try rinsing it in fresh water to remove as much salt as possible. After shaking and blowing out the water, dry the camera in a slightly warm oven for half an hour. Take the camera to a repair shop as soon as possible to see if it can be repaired.

Cold Weather. Low temperatures tend to reduce battery output, stiffen lubricants on your camera's moving parts, and interfere with film advance by stiffening film. It will help to carry the camera under your coat to keep it warm when you are not using it. Cameras can be serviced for extreme cold weather operation by the manufacturer or a qualified repair shop.

Condensation. Condensation can form on the outside of the camera or on the film inside when a camera is moved from the cold outdoors to a warm, moist area indoors. Condensation can also occur in the tropics when a camera is taken out of an air conditioned area. In extreme situations, you can reduce condensation by putting the cold camera in a plastic bag, squeezing out the air, and letting the camera slowly warm to room temperature.

CLEANING

Like any fine instrument, your automatic camera must be protected from dust and moisture. Even with careful handling, however, it is a good idea to clean the film path inside of your camera fairly often, and it is sometimes necessary to clean your lenses. Leave more difficult maintenance work to a reliable camera repair shop.

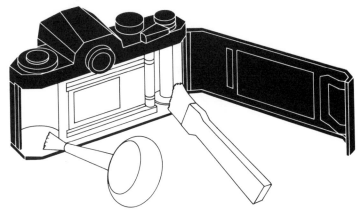

Cleaning the camera. When you load or unload film, blow or brush around the film path and winding mechanism to remove dust and the occasional bit of film that will break off. Angle the camera so the dust falls out and isn't pushed deeper inside. Use a soft cloth if you need to clean the pressure plate on the camera back, but avoid touching the fragile shutter curtains and reflex mirror.

Cleaning the lens. After dusting the lens with brush or blower, fold a piece of camera lens tissue three or four times to increase its thickness, tear off one end, then roll it up to form a tube with a soft brush-like end. Apply a drop of lens-cleaning fluid to the tissue, not directly onto the glass. Clean the lens surface with a circular motion; finish with a gentle wipe with a dry lens-cleaning tissue. Do not reuse tissues and avoid excessive or harsh cleaning; lens glass has a relatively delicate chemical coating.

2 Using Your Canon Camera

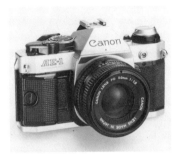

John Littlewood

Your Camera's Controls

The photograph you take is not merely a two-dimensional copy of the scene in front of you, because you and your camera intervene between what you see in front of you and the final photograph. Although features like automatic exposure make photography easier and more enjoyable, all the choices can't be made for you—and as you become more familiar with your camera, you won't want them to be. When you know how to use your camera, you can capture the bright, rich hues of an autumn afternoon, convey the power and speed of Grand Prix racing cars, or render sharp crisp portraits against a softly unfocused background. You cannot expect to achieve sophisticated effects, however, until you have learned to use your camera's three main controls: aperture, shutter speed, and focus.

Shutter Speed
Selector

Aperture
Ring

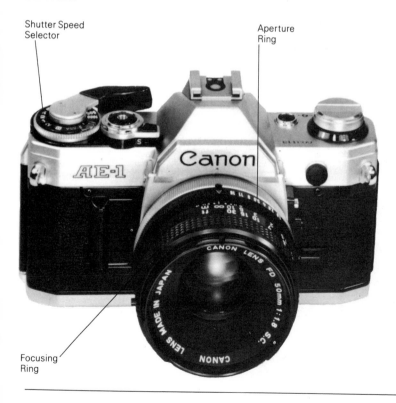

Focusing
Ring

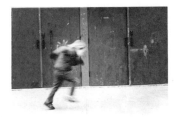
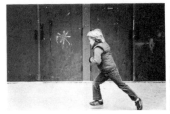

Willard Traub

The shutter *not only affects exposure but also the camera's ability to capture motion. A slower shutter speed (left) gave a blurred image whereas a faster speed (right) froze the action. See pp. 36–37.*

Alan Oransky

The aperture *affects exposure and also determines depth of field (how far into the scene details remain sharp). A small aperture, f/16 (left), gave a considerable depth of field with both foreground and background in sharp focus. A large aperture, f/1.4 (right), produced shallow depth of field with only part of the scene sharp while the rest is out of focus. See pp. 34–35.*

Larry Lorusso

The focus control *determines which part of the photograph will be critically sharp—that is, as sharp as possible with the lens you are using. Notice what happens as the focus shifts from a nearby point (left) to a point farther from the camera (right). See pp. 60–61.*

The Anatomy of Your Automatic Camera

Beneath the deceptively simple exterior of a Canon automatic single-lens reflex (SLR) camera is a highly sophisticated machine capable of performing a complex sequence of operations within a fraction of a second. Knowing something about how your camera works gives you more control over your results and is almost a prerequisite to taking good photographs. At right is a cutaway view of a typical Canon single-lens reflex camera (different models vary somewhat in design). The drawing shows how the camera got its name: for its single lens (some cameras have two) and for the way that the image is reflected upwards for viewing.

LOOKING THROUGH THE VIEWFINDER

When you look through the viewfinder, you are actually looking through the lens of the camera. What you see is similar to what the film will record when you press the shutter button. Light reflected from the subject is gathered by the lens (1) and passes through the aperture (2), which is at its widest opening for a bright view-finder image. The light then bounces off a mirror (3), forms an image on a viewing screen (4), goes up into a mirrored pentaprism (5), which sends it through the viewfinder eyepiece (6) to your eye. Along the way, the brightness of the light is measured by me-tering cells located in the pentaprism (7).

SETTING THE CAMERA'S CONTROLS

Turning the focusing ring (8) on the lens focuses the image sharply by moving the lens elements closer to or farther from the film. You select either an aperture by turning the aperture control (9) or a shutter speed (10) by turning the shutter speed control (11). A camera with a totally automatic mode selects both aperture and shutter speed for you.

PUSHING THE SHUTTER RELEASE BUTTON

Depressing the shutter release button (12) instantly activates a series of events. The mirror snaps up so light will not be blocked when the shutter opens. Metering cells measure the brightness of light as the camera's electronic circuits (13) determine the proper aperture (in shutter-priority mode) or the proper shutter speed (in aperture-priority mode) or both (in totally automatic operation). The aperture closes (stops down) to an opening of the correct size. The shutter opens for the correct length of time to expose the film (14) and then closes. Finally the mirror returns to its viewing position and the aperture returns to its widest opening.

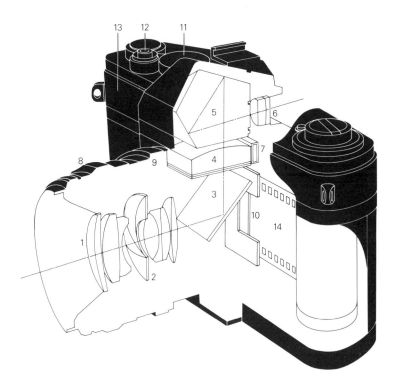

Taking a Picture: Step by Step

The basic steps in using a Canon automatic camera are essentially the same for all models although the arrangement of the various controls may differ. The following checklist can be used as a reminder until you have memorized the procedure. See also your camera's instruction book.

 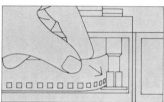

1. Load the camera by attaching the film leader to the take-up spool. Use the film advance lever to advance the film until both edges are engaged by the sprockets. When the film advance lever stops, push the shutter release and continue.

 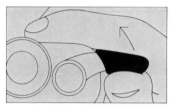

2. Close the back of the camera. Move the film advance lever a full stroke, then release the shutter; repeat two times. The film rewind knob rotates if the film is loading properly; if it does not, open the back to check the loading.

 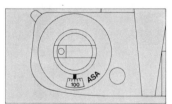

3. Enter the film speed by adjusting the dial marked ASA or DIN. The film speed is found on the film box, cassette, and film instructions. (See p. 80.)

4. Look through the viewfinder and compose the subject. Focus by turning the focus ring on the lens until the image is not split (with a split-image rangefinder) or is sharp (with a ground glass or microprism). (See p. 61.)

5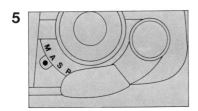

5. Select the mode of exposure: automatic (shutter-priority, aperture-priority, or programmed, if you have a choice) or manual. (See pp. 42–43.) If using flash, see manufacturer's directions for the mode to select.

6a

In aperture-priority mode:
6a. Select the aperture that gives the desired depth of field. Make sure you have a fast enough shutter speed to prevent blur from camera motion and to freeze subject motion. (See pp. 34–35.)

6b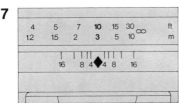

In shutter-priority mode:
6b. Select the shutter speed needed to freeze motion (see pp. 36–37) and to prevent blur from camera motion (p. 76). Check the aperture to make sure it gives the depth of field you want.

7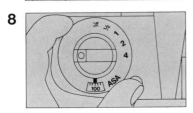

7. Depth of field can be previewed by consulting the scales engraved on the lens barrel or by using a depth-of-field preview button, if your camera has one. (See pp. 64–65.)

8

8. Examine the light on your subject. Sometimes you will need to override the automatic exposure system, such as for a backlit subject or one against a very light or very dark background. (See pp. 46–47.)

9

9. Brace your camera and yourself, hold your breath and slowly depress the shutter button (don't jab it). Just before exposing, recheck the composition, background and edges of the picture.

Choosing an Aperture

Aperture-priority automatic exposure (available on A-1 and AV-1 cameras) lets you choose the size of the lens opening—the aperture—while the camera automatically sets the shutter speed for a correct normal exposure. The size of the aperture (together with the shutter speed) adjusts the amount of light that reaches the film. The aperture is also a major control of depth of field, the area in the image that is acceptably sharp. Stopping down the aperture (making it smaller) increases the depth of field, so that more of the scene is sharp. Opening up to a larger aperture reduces the depth of field and can make a foreground subject stand out sharply against a soft, out-of-focus background.

In aperture-priority operation you can indirectly select the shutter speed. If you want a faster shutter speed, select a wider aperture; the wider aperture lets in more light, so the shutter automatically operates faster. If you want a slower shutter speed, choose a smaller aperture.

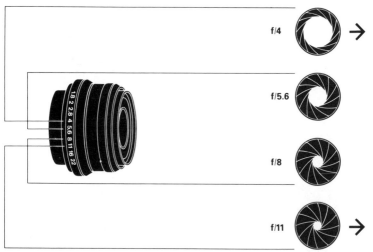

Aperture settings are numbered in f-stops: f/1.4, f/2, f/2.8, f/4, f/5.6, f/8, f/11, f/16, f/22, f/32, f/45 (no lens has all the settings). The smaller the number the larger the aperture opening. Each setting is one "stop" from the next setting: it lets in twice as much light as the next smallest setting. For example, f/5.6 lets in twice as much light as f/8, and half as much as f/4. On some lenses the largest setting may be between steps on the scale—f/1.8, for example, instead of f/1.4.

Aperture controls light. The aperture (along with shutter speed, pp. 36–37) controls the amount of light that reaches the film. If you set a camera for manual exposure operation and change the aperture while leaving the shutter speed the same, you could get the results shown below. At f/4 (top) the film received normal exposure. Stopping down (closing) the lens to a smaller aperture, f/11 (bottom), under-exposed the film and made the picture too dark.

Aperture controls depth of field. The smaller the aperture you use, the greater the depth of field—the area in the scene that will be acceptably sharp in your photograph. Here an A-1 camera was set for aperture-priority automatic exposure; when the aperture was selected the camera automatically set itself to the best shutter speed for a normal exposure. At the larger aperture, f/4 (top), the background is out of focus. At a smaller aperture, f/11 (bottom), the depth of field has increased and more of the scene is sharp. (See pp. 62–63 for other factors that affect depth of field.)

Large Aperture, More Light

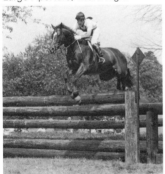

Large Aperture, Less Depth of Field

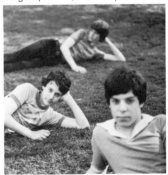

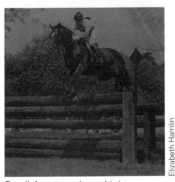

Small Aperture, Less Light

Elizabeth Hamlin

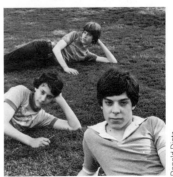

Donald Dietz

Small Aperture, More Depth of Field

Choosing a Shutter Speed

In shutter-priority automatic operation (available on A-1, AE-1, and AE-1 Program cameras and the F-1 when used with Servo EE Finder), you select the shutter speed and the camera automatically sets the aperture for normal exposure. The shutter speed (and aperture) regulate the amount of light entering the camera. The creative side effect of controlling shutter speed is the ability to control motion. The faster the shutter speed, the more sharply the camera will record fast-moving objects and the more it will eliminate blurred images caused by camera motion during the exposure. The longer the shutter is open, the more a moving subject (or moving camera) will "paint" an image across the film, creating blur in the final picture.

Control of the aperture is possible even in shutter-priority operation by changing the shutter speed. If you set the shutter speed slower, the camera will automatically change the aperture to a smaller one. If you select a faster shutter speed, the aperture will be wider.

Shutter speed settings are arranged so that each speed lets in twice the amount of light as the next fastest setting: 1 sec, 1/2 sec, 1/4, 1/8, 1/15, 1/30, 1/60, 1/125, 1/500, 1/1000. (At fractions of a second, only the bottom number of the fraction appears on a shutter speed dial or in a viewfinder display.) The B setting is for long exposures during which the shutter remains open as long as the shutter release button is depressed.

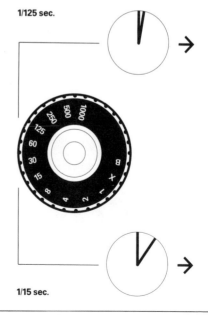

1/125 sec.

1/15 sec.

Shutter speed controls light. The shutter speed controls the amount of light that reaches the film (as does the aperture, pp. 34–35). In the photographs below, the exposure was set manually so that the shutter speed could be changed without changing the aperture. At 1/125 sec (top) the film received normal exposure. Slowing the shutter speed to 1/15 sec (bottom) let in too much light for this scene. The film is overexposed and the final picture is too light.

Shutter speed controls motion. The longer the shutter is open the more that a moving subject will blur in a photograph. Here an A-1 camera was set for shutter-priority automatic exposure so that when the shutter speed was selected the camera automatically adjusted the aperture for a correct normal exposure. At 1/125 sec (top) the subject was moving but recorded sharply in the photograph because the shutter was open for only a brief period. At 1/15 sec (bottom) the shutter was open long enough for the subject to leave a blurred image on the film.

Fast Shutter Speed, Less Light

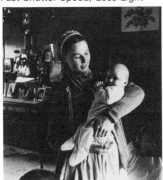

Fast Shutter Speed, Motion Stopped

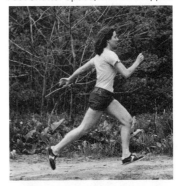

Slow Shutter Speed, More Light

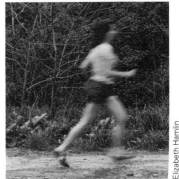

Slow Shutter Speed, Motion Blurred

USDA Photo by Charles O'Rear

Elizabeth Hamlin

Using Shutter Speed and Aperture Together

Both shutter speed and aperture affect the exposure, the total amount of light that reaches the film. A faster shutter speed (letting in less light) can be matched to a larger aperture size (letting in more light), or vice versa, to produce the same exposure. This happens automatically with an automatic camera, but you can also make the adjustments in the settings yourself if your camera has a manual mode.

Although the exposure remains the same when these changes are made, the image alters in other ways. Changing the aperture changes the depth of field; changing the shutter speed changes the way motion is shown. (See opposite.)

For a landscape you might choose a smaller aperture to get more depth of field, even though the correspondingly slower shutter speed might require a tripod to keep the camera steady. To freeze the action at a sporting event, you might choose a faster shutter speed and correspondingly wider aperture, sacrificing depth of field. Choosing your best combination of shutter speed and aperture is one of the creative aspects of photography.

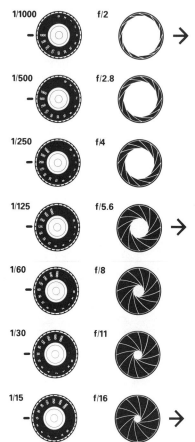

With your camera on automatic, changing one control—the aperture (in aperture-priority operation) or the shutter speed (in shutter-priority operation)—automatically causes the other control to change to keep the exposure constant. The f-stop and shutter speeds above are examples of combinations that allow the same amount of light to reach the film.

Fast Shutter Speed, Wide Aperture

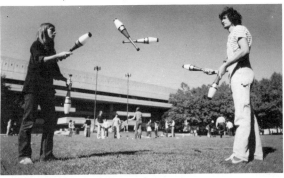

Medium Shutter Speed, Medium Aperture

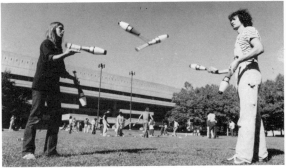

Slow Shutter Speed, Small Aperture

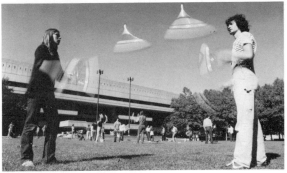

↑
Decreases ——————— Increases
Increases

—————— Depth of Field ——————

—————— Motion Stopping ——————

Increases
Decreases ——————— Decreases
↓

Donald Dietz

With the camera on automatic, any change in the aperture will be matched by a change in the shutter speed, and vice versa. Depth of field (with a small aperture) might be important or you might want to freeze motion (with a fast shutter speed). Which would you prefer here?

3 Getting Good Exposures

Sam Laundon

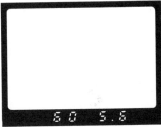

Types of Exposure Control

Correct exposure is achieved when just the right amount of light strikes the film. The amount is controlled by regulating the aperture (the size of the opening through which light enters the camera) and the shutter speed (how long the light is allowed to enter).

In automatic operation, your camera measures the brightness of the light reflected from your subject and then, depending on the exposure mode, sets either the aperture or shutter speed for you (programmed automatic cameras select both). The main reason you would want to change the shutter speed or aperture that the camera selects is to control your ability to freeze or blur motion, or to increase or decrease your depth of field.

Regardless of which exposure mode you use, you can still control all aspects of your pictures. In aperture-priority mode you can change your shutter speed by changing your aperture; in shutter-priority mode you can change your aperture by changing shutter speed. This is possible because in order to keep the exposure constant the camera automatically changes one of the settings when you change the other.

ADVANTAGES AND DISADVANTAGES

Aperture-priority mode (A-1 and AV-1 cameras). You choose the aperture and the camera automatically selects the shutter speed that will produce a correct exposure.

> The aperture is usually more convenient to change than the shutter speed, so camera operation may be easier and faster.

> Gives you direct control over aperture, therefore over depth of field.

> Works on automatic with certain accessories like close-up extension tubes and bellows, mirror lenses with a fixed aperture, or lenses not originally designed for automatic operation.

> You may not notice that the shutter speed has dropped too slow to freeze subject motion or to prevent camera motion.

> You will more often want to pick a specific shutter speed than a specific aperture, but shutter speed can be controlled only indirectly.

Shutter-priority mode (A-1, AE-1, and AE-1 Program cameras and F-1 camera with Servo EE Finder). You choose the shutter speed and the camera automatically selects the aperture that will produce a correct exposure.

> Gives you direct control over shutter speed, therefore over whether moving objects appear sharp or blurred.

> Shutter speed can't change without your noticing, therefore prevents blur caused by camera movement during an unexpectedly long exposure.

> Does not work on automatic with certain close-up attachments and lenses (those that are not coupled to aperture control).

Programmed mode (A-1 and AE-1 Program cameras). The camera automatically selects both the aperture and the shutter speed based on a program built into the camera at the factory.

> Allows you to focus and shoot without taking time to set controls.

> Gives you little control over depth of field or image blur.

Manual mode (A-1, AE-1, AE-1 Program, and F-1 cameras). This nonautomatic mode requires the use of a meter (through the lens of the camera or separately hand-held) to calculate exposure setting. Aperture and shutter speed controls are then set by the photographer.

> Gives you direct control of both aperture and shutter speed.

> Requires your involvement, so may make you more aware of your creative choices.

> Requires a better understanding of camera operation and photographic technique, though not significantly more than you will need anyway if you want creative control over your pictures.

> Somewhat slower than automatic operation.

Multimode (A-1 camera). This camera has several exposure modes including aperture-priority, shutter-priority, programmed, and manual. More information on p. 6.

> Allows you to choose the exposure mode depending on the situation so you can take advantage of a particular mode's strengths while avoiding its weaknesses.

How to Use Your Meter Automatically

Your camera's automatic exposure capability makes photography easy and enjoyable. All you have to do is point the camera at the scene you want to photograph, activate the automatic exposure, focus, and shoot. Because the meter makes its readings through the lens and because you view the scene through the same lens, you see exactly what the meter does. You don't have to guess what part of the scene the meter is reading as you often do if you use a hand-held meter.

In many situations, the meter and its accompanying automatic circuitry operate perfectly, letting in just the right amount of light to expose the film correctly. Automatic exposure functions well in commonly encountered lighting such as is shown opposite: where the light is coming from more or less behind you or where the light is evenly diffused over the entire scene.

Your camera's built-in meter uses a light-sensitive cell to measure the light entering the lens, and depending on the film speed you are using, its electronic circuits compute and automatically set an aperture or shutter speed for a good exposure.

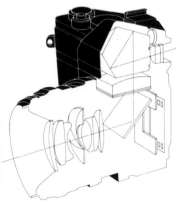

The camera's viewfinder shows not only the scene you are photographing, but also exposure information readouts. The viewfinder above displays shutter speed and aperture settings. As you become more familiar with the effect that these settings have on your picture, you will refer more often to this information display.

Donald Dietz

Automatic exposure works well in most frontally lit scenes in which the light is shining on the subject from more or less behind your camera position—for example, when your subject is facing the main source of light.

A scene in diffused light also usually photographs well with automatic exposure—for example, outdoors on an overcast day or indoors when the light is coming from many light sources (in the classroom scene below, several overhead lights as well as window light illuminated the scene). Diffused light is indirect and soft, with shadows that are not as dark as they would be in a directly lit scene.

Gypsum
$CaSO_4 \cdot 2H_2O$

Elizabeth Hamlin

When Not to Trust Your Automatic Exposure System

Although automatic exposure usually works well, in some lighting situations it will give an incorrect exposure and produce a picture that is too light or too dark. If you learn how to recognize such situations, you can override the automatic exposure system to expose the scene just the way you want it (see pp. 48–51).

The most common scene that gets an automatic exposure system in trouble is a subject that is much darker than its background, such as a subject against a bright sky or with the light coming from behind it (see opposite). The meter doesn't know what it is reading or how light or dark the main subject should be. It simply measures the brightness of the entire scene and calculates an exposure accordingly. If part of the scene is very bright, this will make the reading too high to expose the main subject correctly. The result, unless you take steps to prevent it, will be an underexposed— even silhouetted—subject. Also a problem, although one encountered less often, is a scene in which the subject is brighter than its background or in which the subject has an even, overall tone that is much lighter or darker than middle gray (see pp. 54–55).

Donald Dietz

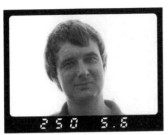

When a backlit subject is metered from the camera position (left), the main subject often appears as an underexposed silhouette against a well-exposed background (right). (In a similar way, a relatively small and light subject photographed against a large and dark background may appear overexposed and too light.)

One way to get a better exposure of a backlit subject is to move close enough so that only the main subject fills the viewfinder. The meter is now no longer overly influenced by the bright background, and the exposure will be calculated for only the main subject. Before stepping back to your original position, set the shutter speed and/or aperture manually as shown in the viewfinder readout. The AV-1 camera, which does not have a full manual mode, does have a backlight control switch which lets you increase the exposure 1½ stops so that a subject against a bright background will receive adequate exposure. See p. 49 for details on other Canon cameras.

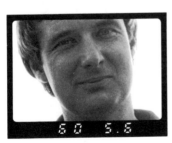

Elizabeth Hamlin

◀ *You don't necessarily have to produce a normally exposed subject. Silhouetting the subject will outline it darkly against a bright background and may be a more interesting picture than a normally exposed one.*

When and How to Override Automatic Exposure

All automatic exposure systems are engineered on the assumption that most scenes average out to a middle gray tone. There are only three types of situations in which you will probably get better results if you override the automatic system.

> A subject surrounded by a much brighter background, for example, a portrait against a bright window or sky. The camera reads the overall brightness and exposes for a middle gray tone on film. The result is that your subject will be underexposed and too dark. You can prevent this by using exposure compensation to increase the exposure.

> A subject surrounded by a much darker background, for example, a sunlit flower against dark trees or a spotlit act on a dark stage. The automatic system will be overly influenced by the dark background and the main subject will be overexposed and too light. Use exposure compensation to decrease the exposure.

> An entire scene that is much lighter or much darker than middle gray. With a snowy landscape, the camera will expose for middle gray and the picture will be too dark. With a very dark subject such as a black horse against a dark barn, the camera will expose for middle gray and the subject will be too light. Use exposure compensation to lighten a scene that is very light overall or darken one that is very dark overall.

Exposure compensation is most important with color slide film because the film in the camera is the end result that you view. It is desirable with color negative film although some correction is possible when prints are made. Even more correction is possible with black-and-white film.

All Canon automatic SLR cameras have some means of overriding the ▶
automatic exposure system when you want to increase the exposure to lighten a picture or decrease the exposure to darken it. The change in exposure is measured in ''stops.'' Each aperture setting is one stop from the next setting. Shutter speeds are also described as being one stop apart; each setting is one stop from the next.

Memory Lock
An exposure memory switch temporarily locks in an exposure so you can move up close to take a reading of a particular area, lock in the desired setting, step back, and then photograph the entire scene. (A-1 and AE-1 Program cameras.)

Backlight Button
Depressing a backlight button adds a fixed amount of exposure, 1 ½ stops, and lightens the picture. It cannot be used to decrease exposure. (AE-1 and AV-1 cameras.)

Exposure Compensation Dial
Moving the dial to 2 or 4 increases the exposure and lightens the picture. Moving the dial to ½ or ¼ decreases the exposure and darkens the picture. The dial can be set in ⅓ stop increments. (A-1 camera.)

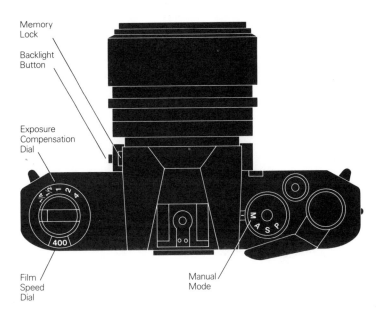

Memory Lock

Backlight Button

Exposure Compensation Dial

Film Speed Dial

Manual Mode

Film Speed Dial
You can increase or decrease exposure by changing the film speed dial. The camera then responds as if the film is slower or faster than it really is. With ASA or ISO-rated film, doubling the film speed (for example, from ASA 100 to ASA 200) darkens the picture by decreasing the exposure one stop.

Halving the film speed (for example, from ASA 400 to ASA 200) lightens the picture by increasing the exposure one stop. (With European DIN-rated films, every increase of 3 in the rating is the same as doubling an ASA-rated film. DIN 21 is equivalent to ASA 100; DIN 24 is equivalent to ASA 200.) You can use the film speed dial for exposure compensation with any camera.

Manual Mode
In manual mode, you adjust the shutter speed and aperture yourself. Exposure can be increased to lighten the picture or decreased to darken it as you wish. (A-1, AE-1, AE-1 Program, and F-1 cameras.)

Quick Guide to Exposure Compensation

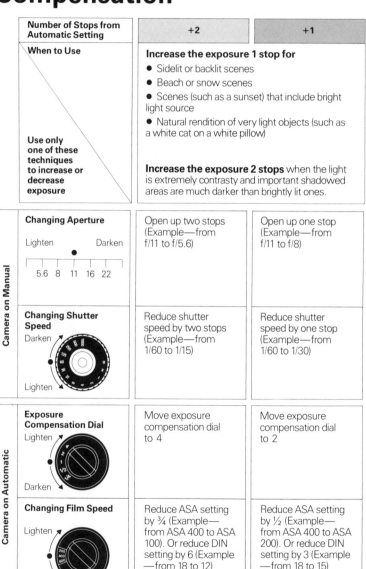

Number of Stops from Automatic Setting	+2	+1
When to Use Use only one of these techniques to increase or decrease exposure	**Increase the exposure 1 stop for** • Sidelit or backlit scenes • Beach or snow scenes • Scenes (such as a sunset) that include bright light source • Natural rendition of very light objects (such as a white cat on a white pillow) **Increase the exposure 2 stops** when the light is extremely contrasty and important shadowed areas are much darker than brightly lit ones.	

Camera on Manual

Changing Aperture Lighten · Darken 5.6 8 11 16 22	Open up two stops (Example—from f/11 to f/5.6)	Open up one stop (Example—from f/11 to f/8)
Changing Shutter Speed Darken Lighten	Reduce shutter speed by two stops (Example—from 1/60 to 1/15)	Reduce shutter speed by one stop (Example—from 1/60 to 1/30)

Camera on Automatic

Exposure Compensation Dial Lighten Darken	Move exposure compensation dial to 4	Move exposure compensation dial to 2
Changing Film Speed Lighten Darken	Reduce ASA setting by ¾ (Example—from ASA 400 to ASA 100). Or reduce DIN setting by 6 (Example—from 18 to 12)	Reduce ASA setting by ½ (Example—from ASA 400 to ASA 200). Or reduce DIN setting by 3 (Example—from 18 to 15)

0	−1	−2
Use the exposure set automatically for scenes that are evenly lit as viewed from camera position and when important shadowed areas are not too much darker than brightly lit ones.	**Decrease the exposure 1 stop for** ● Scenes where the background is much darker than the subject (such as a portrait in front of a very dark wall) ● Natural rendition of very dark objects (such as a black cat on a black pillow) **Decrease the exposure 2 stops** for scenes of unusual contrast, as when an extremely dark background occupies a very large part of the image.	
Leave aperture unchanged	Close down one stop (Example—from f/11 to f/16)	Close down two stops (Example—from f/11 to f/22)
Leave shutter speed unchanged	Increase shutter speed by one stop (Example—from 1/60 to 1/125)	Increase shutter speed by two stops (Example—from 1/60 to 1/250)
Leave exposure compensation dial unchanged	Move exposure compensation dial to ½	Move exposure compensation dial to ¼
Leave ASA or DIN setting unchanged	Multiply ASA setting by 2 (Example—from ASA 400 to ASA 800). Or increase DIN setting by 3 (Example—from 12 to 15)	Multiply ASA setting by 4 (Example—from ASA 400 to ASA 1600). Or increase DIN setting by 6 (Example—from 12 to 18)

Exposures for Hard-to-Meter Situations

When the subject you are photographing is evenly lit and fills the majority of your viewfinder screen, you can usually rely on your automatic exposure system to give a good exposure. There are times, however, when the subject doesn't fill the viewfinder and when the contrast between the bright and dark areas of the picture is so great that automatic exposure will not work well. Examples of this situation are floodlit stage and sports events where the brightly lit center of activity is only a small part of what you see in the viewfinder. If the meter averages light from a small bright area and a much larger dark area to compute the exposure, the result will be that the brightly lit portion of the scene will be overexposed. In these and similar situations, you will get a better exposure if you switch to manual and use the settings in the following table.

Hard-to-Meter Situations

Subjects	Film Speeds							
	ASA 25–32 DIN 15–17		ASA 50–80 DIN 18–20		ASA 100–160 DIN 21–23		ASA 200–400 DIN 24–27	
	Suggested Exposure Times							
Outdoors/Night								
Streets	1/15	f/2	1/30	f/2	1/60	f/2	1/125	f/2
Night club and theatre districts, brightly lit	1/30	f/2	1/60	f/2	1/60	f/2.8	1/125	f/2.8
Neon and other lighted signs	1/30	f/2.8	1/60	f/2.8	1/60	f/4	1/60	f/5.6
Christmas lighting	1	f/2.8	1	f/4	1/2	f/4	1	f/4
Floodlighted buildings, fountains/ monuments	1/2	f/2	1/4	f/2	1/8	f/2	1/15	f/2
Skyline—distant lighted buildings	4	f/2	2	f/2	1	f/2	1	f/2.8
Skyline—10 min. after sunset	1/30	f/2.8	1/30	f/4	1/60	f/4	1/60	f/5.6
Fairs/amusement parks	1/8	f/2	1/15	f/2	1/30	f/2	1/60	f/2

Subjects	Film Speeds							
	ASA 25–32 DIN 15–17		ASA 50–80 DIN 18–20		ASA 100–160 DIN 21–23		ASA 200–400 DIN 24–27	
	Suggested Exposure Times							
Fireworks, on ground	1/30	f/2	1/30	f/2.8	1/60	f/2.8	1/60	f/4
Fireworks, in air	Keep shutter open for several bursts.							
		f/5.6		f/8		f/11		f/16
Fires/bonfires/ campfires	1/30	f/2	1/30	f/2.8	1/60	f/2.8	1/60	f/4
Lightning	Keep shutter open for several flashes.							
		f/4		f/5.6		f/8		f/11
Landscapes by moonlight			30 sec.	f/2	15	f/2	8	f/2
Snow scenes by moonlight	30 sec.	f/2	15	f/2	8	f/2	4	f/2
Full moon	1/125	f/8	1/125	f/11	1/125	f/16	1/250	f/16
Half moon	1/60	f/5.6	1/60	f/8	1/125	f/8	1/125	f/11
Outdoors/ Daytime								
Bright sunlight on light sand or snow	Use exposure compensation (see pp. 36–39) to open up +1 stop.							
Backlighted subjects in bright sun	Use exposure compensation (see pp. 36–39) to open up +2 stops.							
Rainbows	For richer colors use exposure compensation (see pp. 36–39) to stop down 1/2 stop.							
Indoors/ Artificial light								
Close-up by candlelight	1/2	f/2	1/4	f/2	1/8	f/2	1/15	f/2
Christmas trees	1	f/2.8	1	f/4	1/2	f/4	1/4	f/4
School stage or auditorium	1/8	f/2	1/15	f/1.4	1/15	f/2	1/30	f/2
Boxing, wrestling	1/30	f/2	1/60	f/2	1/125	f/2	1/125	f/2.8
Stage shows, average light	1/15	f/2	1/30	f/2	1/60	f/2	1/125	f/2
Stage shows, bright	1/60	f/2	1/60	f/2.8	1/60	f/4	1/125	f/4
Circus, floodlighted act	1/15	f/2	1/30	f/2	1/60	f/2	1/125	f/2
Circus, spotlighted act	1/60	f/2	1/125	f/2	1/125	f/2.8	1/125	f/4
Ice shows, floodlighted act	1/30	f/2	1/60	f/2	1/125	f/2	1/125	f/2.8
Ice shows, spotlighted act	1/60	f/2	1/125	f/2	1/125	f/2.8	1/125	f/4

Adapted from information © Eastman Kodak Company.

How Your Meter Works

How does your meter decide what exposure to give a scene? You can use your meter more successfully if you know a little more about how it "thinks." All meters are calibrated on the assumption that in most scenes there will be a few dark shadows, many gray mid-tones, and a few bright highlights, and that all of these tones together will average out to a tone of medium brightness called *middle gray*. When the meter reads the brightness of a scene, it doesn't actually think at all; it simply calculates an exposure that would reproduce a tone of that brightness correctly as middle gray.

A meter will translate a white jacket, gray jacket, and black jacket all into middle gray (opposite, left and center). This is really not a problem, because you can override the meter's decision (opposite, right), but you do have to stop for a moment and decide if the scene is "average" and therefore will photograph well on automatic or if, as in a snowy landscape or other nonaverage scene, you should override the automatic functioning. See pp. 46–51 for information on exposure compensation, the means of overriding the camera to get the exposure you want.

Meter Weighting. *Most light meters do not give equal emphasis to all parts of the scene they are metering; their readings are weighted to give greater emphasis to the center of the scene. Most photographs have the most impor-tant object near the center, so center weighting helps concentrate the reading on this area. Land-scapes are usually shot horizon-tally, and a slight bottom weight-ing helps keep a bright sky at the top of the picture from unduly influencing the reading.*

If your main subject occupies most of the center of the scene in the viewfinder, the meter will probably do a good job of reading the scene. If the subject is signifi-cantly off center or much brighter or darker than the background, then your meter may not read it accurately.

Original Scene	Camera on Automatic	Using Exposure Compensation

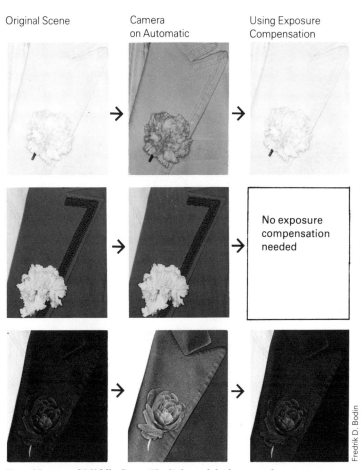

No exposure compensation needed

Fredrik D. Bodin

Your Meter and Middle Gray. *The light and dark areas of most scenes average out to middle gray. If your subject is of a more or less uniform tone and fills the viewfinder frame, it will photograph as middle gray regardless of its actual tone. The result can be an incorrect exposure if your subject is of an even tone other than middle gray or if it occupies a small area of the viewfinder image and is against a much lighter or darker background.*

In the series of photographs above, the original scenes (left) were photographed on automatic (center). All of the scenes—black, gray, and white—appear as middle gray. Using exposure compensation (pp. 48–51), the white scene was then rephotographed to increase the exposure and make the jacket white, not gray. The black jacket was rephotographed to decrease the exposure and make the jacket black, not gray. The gray jacket needed no exposure compensation.

4 Getting Sharp Pictures

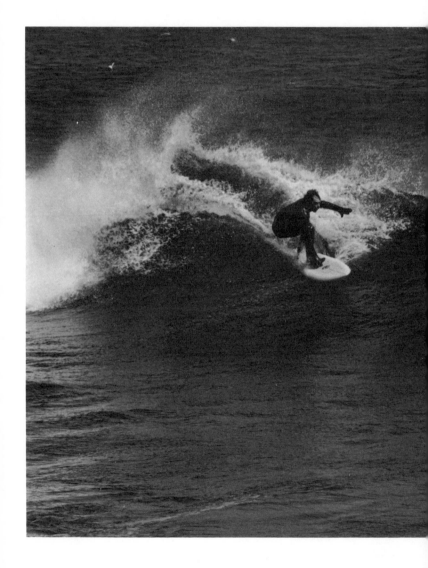

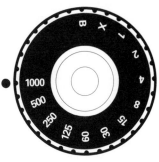

Fredrik D. Bodin

What Makes Pictures Unsharp

Unsharp pictures are rarely the result of camera or lens problems. If your photographs aren't always as sharp as you want them to be, you are probably experiencing one of the problems described below. All of your photographs don't have to be sharp, however (see pp. 74–75).

Focus. *If nothing in your photograph is sharp or if your central subject is not sharp but other parts of the photograph are, your camera was improperly focused. (See pp. 60–61.)*

Depth of Field. *If your central subject is sharp but the background or foreground is less so, you probably didn't use a small enough aperture to get the depth of field you wanted. (See pp. 62–63.)*

Fredrik D. Bodin

Larry Lorusso

Larry Lorusso

▲ **Camera Movement.** *One major cause of unsharp pictures is camera movement during the exposure. The photograph will be blurred all over and no part of it will appear sharp. To eliminate blur caused by camera movement, select a fast enough shutter speed or mount the camera on a tripod. (See pp. 76–77.)*

▼ **Subject Movement.** *When some of the picture is sharp but movement appears blurred, the cause is a shutter speed too slow to freeze the action. The amount of blur of a subject can be affected by your shutter speed, the speed and direction of the subject's movement in relation to the camera, the distance between subject and camera, and the focal length of the lens. (See pp. 70–73.)*

Larry Lorusso

Focus and Depth of Field

If you look closely at your photographs you may find some in which all parts of the scene are not equally sharp. Some objects may be very sharp, others less so, and some entirely out of focus, depending on how far they were from the camera. This variation in sharpness throughout a scene is the result of two major characteristics of your lens, *focus* and *depth of field*.

Focus determines which part of your photograph will be "critically sharp"—as sharp as the lens is capable of making it. The farther objects get from this critically sharp plane—going away from or going toward the camera—the less sharp or softer they will appear. At a certain distance, things will become so soft that they will appear definitely out of focus. The area from the foreground to the background where objects are acceptably sharp is called the depth of field. Objects outside of this zone will be out of focus in your photograph.

Suppose you were photographing a receding picket fence and focused your camera at 9 ft (2.7 m). You would see that the pickets about 9 feet from you were critically sharp: *these pickets fall on the* plane of critical focus. *The pickets going away from this plane in either direction would get increasingly softer the farther they are from this critical plane; at certain points these pickets would become noticeably out of focus and blurred. Between the* plane of near focus *(6 feet, or 1.8 meters, in this example), and the* plane of far focus *(20 feet or 6 meters), the pickets would be acceptably sharp: this area is called the* depth of field. *As you move the focus ring on your lens, the plane of critical focus, as well as the planes of near and far focus, will move toward or away from you.*

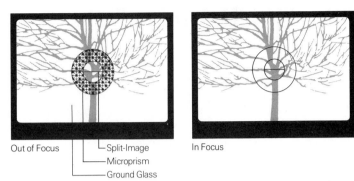

Out of Focus └─Split-Image In Focus
 ├── Microprism
 └── Ground Glass

Focusing with the Viewfinder. *As you look through the viewfinder and turn the focus ring, you will see the most sharply focused area (the plane of critical focus) move away from the camera position or towards it. This critically sharp plane is shown in the viewfinder by a split image coming together, by a microprism circle becoming clearer, and/or by the image becoming sharper on the ground glass. It is always helpful to find a sharp vertical edge to focus on with the split image, especially in low light situations. If your subject doesn't have such an edge, you can focus on one at an equal distance from the camera.*

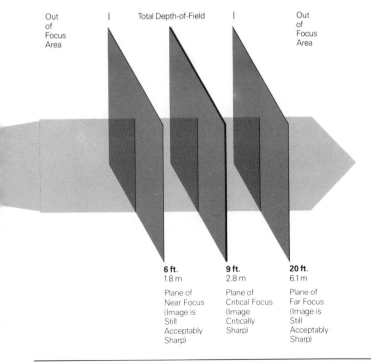

Out of Focus Area | Total Depth-of-Field | Out of Focus Area

6 ft.
1.8 m

Plane of Near Focus (Image is Still Acceptably Sharp)

9 ft.
2.8 m

Plane of Critical Focus (Image Critically Sharp)

20 ft.
6.1 m

Plane of Far Focus (Image is Still Acceptably Sharp)

Controlling Depth of Field

In some pictures (such as landscapes) you may want great depth of field—everything in the scene sharp from foreground to background. In others (such as portraits taken against a distracting background) you may want shallow depth of field to feature the central subject against an out-of-focus (and so less prominent) background. Three major factors control depth of field: aperture, lens focal length, and camera-to-subject distance.

Aperture. The smaller the aperture, the greater your depth of field. The photograph below left was taken using a large aperture (f/1.4) and has shallow depth of field. The one at right was taken at a small aperture (f/16) and has much greater depth of field.

Lens Focal Length. *The longer the focal length of your lens, the shallower the depth of field. The photograph taken with a 135mm lens (above left) has less depth of field than the one taken with a shorter, 35mm lens (above right).*

Camera-to-Subject Distance. *The closer the camera is to your subject, the less depth of field you get. With the camera focused close to the subject (below left), there is less depth of field than if the camera is focused at a greater distance (below right).*

Alan Oransky

Previewing Depth of Field

How can you preview how much depth of field you will have in the final photograph? Is your depth of field great enough to have objects in both the near foreground and distant background in sharp focus? Is it narrow enough to isolate a central subject against a soft, out-of-focus background? Knowing how to predict what areas will be sharp can be crucial to getting the picture you really want. You can read the extent of the depth of field off your lens barrel (below) or you can stop down your lens to get a visual preview (opposite). Canon also provides tables that list the depth of field for various lenses, f-stops, and focusing distances.

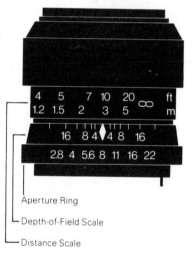

Most fixed-focal-length lenses for 35mm cameras are engraved to show the depth of field for different aperture settings. (Zoom lenses, which have variable focal lengths, may not have this feature.)

The focus index ◊ points to the distance (in meters or feet on the distance scale) at which the camera is critically focused. On either side of the focus index are pairs of aperture markings. Lining up the pair for a given aperture (for instance, f/8 for the lens at right) against the distance scale shows the extent of the depth of field (here, 7 ft, 2 m to 17 ft, 4½ m).

Aperture Ring

Depth-of-Field Scale

Distance Scale

When you look through your viewfinder at a scene, your actual depth of field is not evident because the lens is set at its widest aperture to give a bright viewfinder image. Some Canon cameras have a preview button that when depressed stops the aperture down to the one you have set on the lens. When the light is bright enough or your chosen aperture large enough, this button can be used to give an idea of which parts of the scene will be sharp. If they are sharp on the viewfinder screen they will be sharp in your photograph.

Normal Viewfinder Image

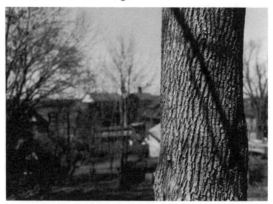

With Preview Button Depressed

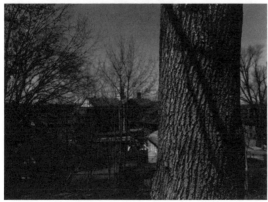

Joe DeMaio

Focusing for Maximum Depth of Field

Sometimes a scene includes important objects that are relatively close to the camera as well as other equally important objects in the distance. What do you focus on if you want both to be sharp? If you focus on the far distance (infinity, in photographic terms, marked ∞ on the lens's distance scale), the foreground may be out of focus. If you focus on the foreground, distant objects may be out of focus. See below for a way to get the maximum depth of field (the maximum distance between near and far points that will be acceptably sharp).

Even when focused for maximum depth of field, some of the scene may still appear out of focus as you look through the view-finder because you are viewing through the lens's widest aperture. When the shutter is released the aperture will close down to the preselected shooting aperture, increasing the depth of field. (See pp. 64–65.)

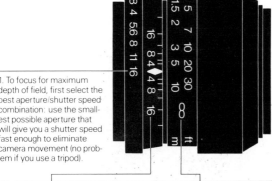

1. To focus for maximum depth of field, first select the best aperture/shutter speed combination: use the smallest possible aperture that will give you a shutter speed fast enough to eliminate camera movement (no problem if you use a tripod).

2. Locate the f-number (here f/16) on the depth-of-field scale on the lens barrel. The f-number appears twice, once on each side of the central arrow that marks the distance on which you are focused.

3. Move the focusing ring so, that the infinity symbol (∞) on the distance scale is opposite your f-number (f/16) on the depth-of-field scale.

4. The distance scale now shows how much of the scene will be acceptably sharp—everything between the two numbers (the 2 f/16's). Here, from 2.5m (8 ft) to infinity.

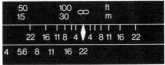

You can significantly increase your depth of field (the area of acceptably sharp focus) by using the markings on the lens barrel. Above: the photographer focused on the batter in the far distance (infinity, ∞). At f/22 everything from infinity to 50 ft, 60 m was sharp, but not the ballplayer in the foreground. Below: by moving the ∞ mark on the distance scale so that it was opposite the f/22 mark on the depth-of-field scale, the photographer increased the depth of field so that everything was sharp from ∞ to 26 ft, 8 m, including the entire foreground.

Donald Dietz

Focus: Close-up and Selective

Barbara M. Marshall

Close-up photography requires critical focusing, because a very short camera-to-subject distance produces very shallow depth of field (see pp. 146–147). In the illustration above, only a small portion of the subject is sharply in focus, with the rest out of focus.

If desired, you can increase depth of field to some extent (see pp. 62–63). Using a faster film allows for a smaller aperture, increases the depth of field and brings more of the main subject into sharp focus. Moving the camera farther from the subject or using a shorter focal length lens will also increase depth of field, but will reduce the size of the main subject.

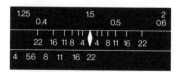

Depth of field is shallow in a close-up. *With the lens focused at 1.5 ft, .47m, the only sharp area is between 1.3 ft, .4 m and 1.9 ft, .55 m, even with an aperture of f/22.*

Barbara M. Marshall

You won't always want maximum depth of field. Sometimes you want to emphasize your subject against a less sharp background. The longer the focal length of your lens, the less depth of field you will have, but selective focus is possible even with a moderately short-focal-length lens. Begin by choosing a wide aperture. (In bright light, a slow film will make this easier since fast film may not allow a large enough aperture.) Move close to the main subject and focus on the subject; the closer you are, the more the background will be out of focus. If your camera has a depth-of-field preview button, it will show how much the background is out of focus. The depth-of-field scale on the lens will tell you where the depth of field ends—that is, where objects begin to be visibly out of focus—but unlike the preview button it won't give an indication of how much out of focus a particular part of the scene will be. (See pp. 64–65.)

Minimum Depth of Field. *The lens is set to a wide aperture (f/1.8) and focused with camera close to the subject.*

Photographing Motion

With the shutter open, any movement of the subject is projected as a blurred image onto the film. How much the image blurs depends on how long the shutter is open: a faster shutter speed diminishes blur and a slower shutter speed accentuates it. Depending on your intent, blur can be eliminated, reduced, or used to convey a feeling of speed and motion in your photograph. The amount of blur in a photograph is also affected by the speed and direction of the subject, its distance from the camera, and the focal length of the lens.

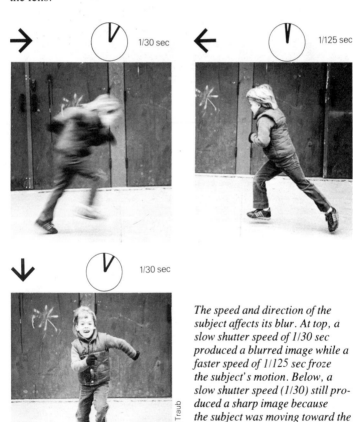

1/30 sec

1/125 sec

1/30 sec

Willard Traub

The speed and direction of the subject affects its blur. At top, a slow shutter speed of 1/30 sec produced a blurred image while a faster speed of 1/125 sec froze the subject's motion. Below, a slow shutter speed (1/30) still produced a sharp image because the subject was moving toward the camera and did not cross enough of the film to blur.

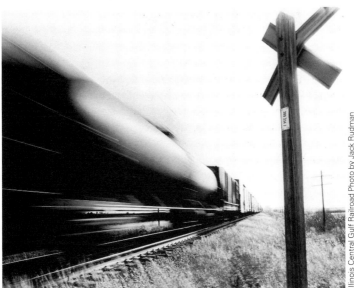

Illinois Central Gulf Railroad Photo by Jack Rudman

The distance from the camera to a moving object affects the amount of blur in a photograph. The part of the train on the left of the image is close to the camera and appears very blurred while the part to the right—moving at the same speed but farther from the camera—appears sharp and distinct. The closer a moving object is to the camera, the faster the shutter speed must be to freeze the action.

A longer focal length lens used from the same camera-to-subject distance emphasizes a moving subject's blur. The photograph at left, taken with a 50mm lens, appears to freeze the moving subject, whereas the one at right, taken with a 135mm lens, shows a larger subject and more blur. The longer lens has the same effect as reducing the camera-to-subject distance, affecting the image just as if the same lens were moved closer to the subject.

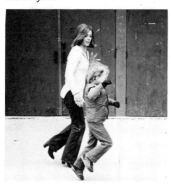
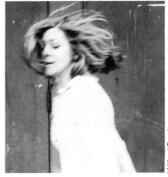

Willard Traub

More About Motion

You may not be able to use a shutter speed fast enough to freeze motion when the light is too dim or when the subject is moving too fast. At these times you may choose to let the image blur to convey a feeling of speed. If you prefer to freeze the action, however, try panning (moving the camera in the direction the subject is moving), anticipating and shooting at the peak of action, or using an electronic flash.

Panning. When a subject is moving, its image on the film plane of a camera moves unless the camera is moving also. If you pan (move the camera with the subject during the exposure) much as you would follow a moving bird with a telescope, the motion of the main subject will remain relatively stationary on the film plane. The blurring of the background as the camera pans across it serves to emphasize the subject's motion. Panning takes practice. Try following moving subjects in the viewfinder while slowly panning the camera. Swing your body smoothly to keep the subject stationary in the viewfinder. Squeeze the shutter release gently while you are moving and follow through, as you would with a tennis stroke.

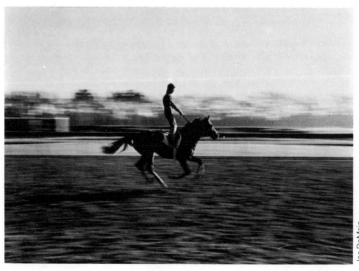

Joe DeMaio

Joe Wrinn

The Peak of Action. *In many motions there is a peak of action—a moment when the motion is momentarily reduced or suspended. To get a sharp image of a diver at the peak of his dive or a gymnast at the top of her jump, learn to anticipate the peak of action and press the shutter release at that moment.*

Flash to Freeze Action. *Although the camera shutter speed used with flash is only 1/60 sec (1/125 sec at the fastest), the flash of light itself is so fast that it will easily record almost any moving subject completely sharp. Moving children, athletes, machinery, or any subject in motion that you want to see sharp will be easy to photograph with flash (see pp. 126–139).*

Jerry Howard

Sharpness Isn't Always Necessary

Pictures don't have to be sharp to be effective. Out-of-focus effects can soften the image, making it more romantic; blurring can give the image a feeling of speed and motion. Greatly exaggerated effects can become interesting abstractions.

Results are hard to predict because so many variables are involved, including lens focal length, subject motion, depth of field, and so on. Experiment with one or more techniques until you develop an intuitive feeling for how various camera settings affect the way subjects appear in the final photograph.

When photographing in dim light you will normally have to use a slow shutter speed, even if the camera is set to its largest aperture. At a slow shutter speed, if you photograph a moving subject while holding the camera steady, the image will be blurred in the picture. The blurred image of the saxophone player below gives a strong feeling of motion and energy that might be lacking in a more "frozen" picture.

Deliberately making part of an image soft by having it appear out of focus is a useful technique for giving increased importance to the part that remains sharp. In this photograph a large aperture was used and the camera positioned close to the horse. With the resulting shallow depth of field, the background is completely out of focus and attention is drawn to the sharp foreground figure.

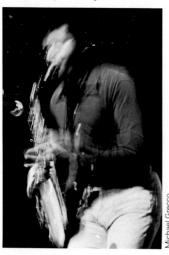

Michael Grecco

Fredrik D. Bodin

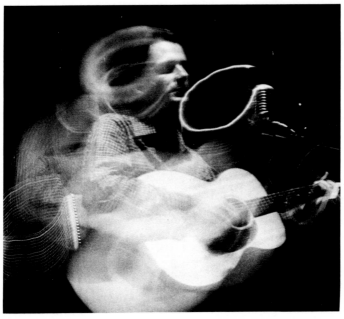

Ken Kobre

Images can be blurred not only by having the subject move but also by your moving the camera during a long exposure. The circular path of the highlight on the microphone in this photograph shows how the camera was moved during the exposure.

In this woodland scene, the shutter was open for several seconds, long enough for the waterfall and stream to blur into soft white streaks. The photographer set the camera on a tripod so the surrounding rocks would stay sharp during the long exposure.

Larry Lorusso

Holding and Supporting Your Camera

Unwanted camera movement during the exposure is probably the major cause of unsharp photographs. You can reduce this problem at fast shutter speeds simply by holding the camera steadily and depressing the shutter release smoothly. At slow shutter speeds, particularly with a long-focal-length lens (those over 50mm), you will need a camera support.

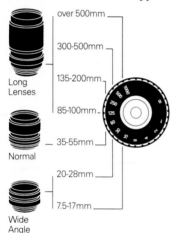

Long Lenses

Normal

Wide Angle

over 500mm
300-500mm
135-200mm
85-100mm
35-55mm
20-28mm
7.5-17mm

Minimum Shutter Speeds for Hand-Holding. *Longer lenses magnify camera movement and therefore require faster shutter speeds to avoid blurring. A rule of thumb is never to hand-hold the camera at a shutter speed lower than your lens' focal length. You can probably hand-hold a 50mm lens at 1/60 second without getting blur in your pictures, but an 85mm lens needs 1/125 sec or faster.*

Holding the Camera for Horizontal Photographs. *Hold the camera in your right hand with the forefinger on the shutter release button. Use your left hand to focus and change apertures. Use your right forefinger to depress the shutter release.*

Holding the Camera for Vertical Photographs. *You can support the camera with either your right or your left hand. Use your right hand to depress the shutter release button and to advance the film. Your left hand can be used to focus and change apertures.*

Camera Supports. *When the shutter speed is slower than your lens' focal length, you need a tripod, clamp, or other support to eliminate camera movement. If a tripod isn't available, try to steady the camera on a nearby wall, table, or other surface. Pressing the shutter release jerkily can still shake the camera. You can prevent this by using a cable release or, if your camera has one, a self timer.*

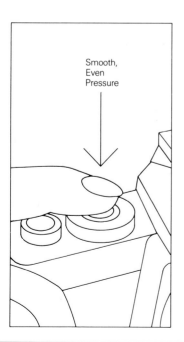

Smooth,
Even
Pressure

Depressing the Shutter Release. *Although you may "snap" a picture, do not snap your finger down on the shutter release. Always depress it smoothly and evenly without jerking the camera. Brace yourself first (elbows against your body) and hold your breath. Doing this well enough to get sharp pictures at slow shutter speeds takes practice, so use a tripod or other support until you learn your limits.*

5 Choosing and Using Film

Lou Jones

Buying Film

Standing in front of a camera store film display is definitely not the time to decide what kind of film to buy. This chapter will help you choose film on the basis of what you want your film to do for you. Before you buy, ask yourself:

> Do I want black-and-white or color?

> Do I want prints or slides? (See pp. 82–83.)

> Will I be shooting in daylight or tungsten light, or with electronic flash? (See pp. 84–85.)

> How many exposures do I want on a roll?

> What film speed do I need for the light levels I will be shooting in? (See pp. 88–89.)

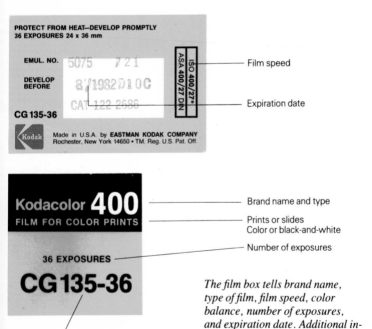

The film box tells brand name, type of film, film speed, color balance, number of exposures, and expiration date. Additional information is usually listed on an instruction sheet packed inside.

Film speed. This is labeled on the film box as an ASA, DIN, or ISO number and indicates how sensitive the film is to light. The higher the number the more sensitive the film. Fast films are good in most situations but are almost essential when shooting in dim light or with a lens with a relatively small maximum aperture (e.g., f/4) often found on long-focal-length lenses. (See pp. 88–89 for more on film speed.)

Color balance. This indicates what light sources will give the most accurate renditions with color film. Daylight-balanced color film is designed to record colors accurately in midday daylight or when used with electronic flash. Tungsten-balanced color film gives good results with ordinary household lamp bulbs or with professional tungsten lamps. A few color films are balanced for use with the slightly different 3400K photolamps (type A film). (For more on color balance see pp. 84–85.)

Expiration date. Film can be used after this date but it gradually decreases in quality, losing contrast, color balance, and speed.

Brand name and type. Various brands of film record your images somewhat differently, particularly with color film. The differences—primarily in color balance and grain—are subtle but definitely noticeable. Try a variety of brands: you may find one you like better than others.

Prints or slides. Print film is generally more expensive than slide film when the costs of the film and processing are added together. Slide film, however, requires a projector to view properly and slides cannot be conveniently viewed in albums. Slide film is also more sensitive to small variations in exposure because corrections cannot be made as they are when negative film is enlarged from the negative to a print. Your choice, like the brand you use, should be based on your own personal preferences.

Number of exposures per roll. 36-exposure rolls are economical. If you shoot infrequently or if you shoot in color and often switch back and forth between indoor scenes (where tungsten-balanced film is best) and outdoor scenes (where daylight-balanced film is best), then smaller 12-, 20-, or 24-exposure rolls may be more practical for you. If economy is vitally important, some films come in 100-foot rolls and you can buy empty cassettes and a bulk film loader so you can load up rolls of film yourself.

Format. Most film manufacturers use a code to identify the film type. In most cases the number 35 will appear in this code to identify 35mm film.

Storage. Films keep best stored in a cool place. A refrigerator or freezer is good for extended storage, with film in moisture-proof wrapping. Let films come to room temperature before unwrapping to prevent condensation. Films stored in warm places deteriorate rapidly. Avoid car glove compartments or rear window shelves, particularly in the summer. Avoid storage near radiators in winter.

Choosing a Color Film

Color film is available in two main types: reversal film (for slides) and negative film (for prints). Reversal film (usually designated "-chrome" as in Kodachrome or Agfachrome) is processed directly into transparencies (also called slides), which require a viewer or projector for viewing. Negative film (usually designated "-color" as in Kodacolor or Fujicolor) is processed to produce a negative which is then used to make a print.

COST

It is less expensive to buy and process into slides a roll of reversal film than it is to buy, process, and print a roll of negative film. Many photographers use color slide film exclusively; for those occasional great photographs, they have prints made from the slide.

EXPOSURE

Reversal films require more exact exposures than do negative films because the film in the camera actually becomes the final image for viewing. Reversal film will tolerate only about ½-stop underexposure before colors begin to look too dark and even less overexposure before colors look too light. Negative films have somewhat more latitude or exposure tolerance (up to about 1 stop underexposure, 1 to 2 stops overexposure) because some corrections can be made when the negative is printed.

COLOR BALANCE

All color films are designed to give their most accurate color rendition under light of a particular color balance (see pp. 84–85). When used under light of a different color balance the picture becomes unnaturally colored. Certain high-speed color negative films such as Kodacolor 400 have a more or less universal color balance and can be used without filtration in most kinds of light.

COLOR RENDITION

No film can exactly reproduce the colors in a scene. How colors look in your photographs (particularly in slide form) depends in part on the brand and type of film you use. Try a few of the major types, compare the results, and choose the one you like best.

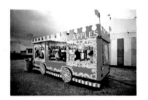

An original scene photographed using negative (print) film gives you a negative from which a positive image on paper can be printed. If you use reversal (slide) film, the usual end result is a transparency or slide. The slide can also be printed onto paper either by having an internegative made or by direct printing with a reversal printing process.

Original
Scene

Reversal
Film

Negative
Film

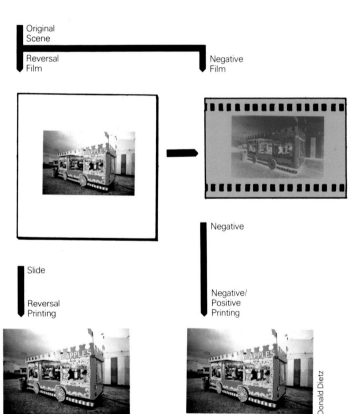

Negative

Slide

Reversal
Printing

Negative/
Positive
Printing

Donald Dietz

Matching Color Film and Light Source

White light is made up of a mixture of all the visible wavelengths (colors) in the light spectrum. The amount of each color making up the combination affects the true color of the "white" light; these amounts vary with the source of the light and, outdoors, the atmospheric conditions through which it passes. Household bulbs have a warm red cast to their light, whereas sunlight shifts colors as the time of day and weather change. Although we notice only the extremes of these changes—for instance, a bright sunset—color film is sensitive to even small changes in the overall hue of the light it records.

Color Temperature. As the proportions of the colors making up white light change so does the overall cast of the light. These various combinations can be measured (with a color temperature meter) and arranged on a scale like the one on the right. The color temperature meter is calibrated in units called degrees Kelvin (just like heat temperatures can be arranged in degrees Centigrade on a thermometer), ranging from the low red temperatures to the high blue ones.

Color film is designed (color balanced) to record colors accurately when the scene is illuminated by a light from a narrow portion of the scale. When the light is other than the one for which the film is balanced, the photograph will take on the overall color cast of the light being used.

Daylight film, for instance, is balanced for 5500 K, the color temperature of light from the sun at midday. When used earlier or later in the day, the image shifts to a warmer red-orange cast.

Film	Color Temperature	Type of Light
	12,000 K and higher	Clear skylight in open shade, snow
	10,000 K	Hazy skylight in open shade
	7000 K	Overcast sky
	6600 K	
	5900-6200 K	Electronic flash
Daylight	5500 K	Midday
	4100 K	
	3750 K	
	3600 K	
	3500 K	
Type A (indoor)	3400 K	Photolamp
Tungsten (indoor)	3200 K	
	3100 K	Sunrise, sunset
	3000 K	
	2900 K	100 watt tungsten bulb
	2800 K	
	1900 K	Candlelight, firelight

Photographing in Fluorescent Light. *Fluorescent light presents a special problem because the color balance depends on the type of fluorescent tube and its age, and does not match either daylight or tungsten color films. The light often gives an unpleasant greenish cast to pictures. To reduce the greenish cast, try a fluorescent filter (see filter chart, p. 123). Daylight film will give a better balance than tungsten film if you use no filter.*

Fluorescent Light

Elizabeth Hamlin

Daylight Film in Daylight

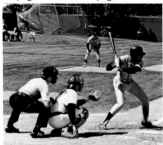

Tungsten Film in Daylight

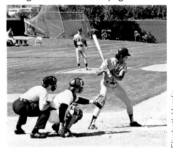

Elizabeth Hamlin

Photographing in Daylight. *Daylight-balanced film reproduces daylight scenes in natural colors; but tungsten film used in the same light gives the photograph a blue cast. Tungsten film can be used in daylight if you shoot through an amber #85 filter.*

Tungsten Film in Tungsten Light

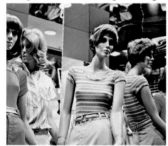

Daylight Film in Tungsten Light

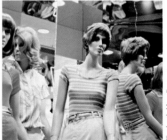

Elizabeth Hamlin

Photographing in Tungsten Light. *Tungsten-balanced film gives natural colors when used under tungsten light, but daylight film used in the same light gives orange tones. Daylight film can be used in tungsten light if you put a blue #80 filter on the lens.*

Using Color in Your Photographs

Color in a photograph can enhance the subject matter, be neutral and unobtrusive, or be a distracting element.

David A. Krathwohl

Right: bright, contrasting colors are vibrant in this picture taken inside a hot air balloon on a sunny day. Below: early morning fog and an overcast sky made colors muted and bluish in this farm scene. Objects farther away were more muted by the fog than those closer to the camera.

M. Woodbridge Williams

Larry Lorusso

Above: the colors of certain objects like human skin and green grass are familiar and the eye expects them to stay within a certain normal range, as here. Too much shift away from normal will be readily noticeable. Below: considerable variation is tolerated in sunsets or scenes where colors are not known. You can control colors in a photograph to a certain extent with filters over the lens.

Rick Ashley

Film Speed and Grain

Film speed is a measure of a film's sensitivity to light. The faster the speed, the less light needed to obtain an exposure. Under a given light level, a fast film requires a shorter shutter speed or smaller aperture (or both) than a slow film does to produce the same exposure. Film speeds are designated by a film speed number; the higher the number, the faster the film.

An ASA rating is commonly found on films in English-speaking countries. Each time the ASA rating doubles, the speed of the film doubles. ASA 200 film is twice as fast as ASA 100 film, half as fast as ASA 400 film. You can also describe this speed difference in stops of exposure. Because a 1-stop change equals a doubling (or halving) of exposure, the ASA 200 film is 1 stop faster than the ASA 100 film, 1 stop slower than the ASA 400 film.

A DIN rating is often found on European films. Each change of 3 in the rating equals 1 stop difference in speed. A film rated DIN 24 is twice as fast (1 stop) as a film of DIN 21 and half as fast as a film rated DIN 27. (To convert from ASA to DIN see the conversion chart on p. 92.)

An ISO rating combines the ASA and DIN numbers—for example, ISO 200/24°, ISO 100/21°.

Barbara M. Marshall

Both color and black-and-white film consist of small light-sensitive silver halide particles suspended in layers of emulsion. One of the ways film is made faster (more sensitive to light) is by increasing the size of these particles. The larger particles in fast film tend to overlap. When film is developed, these particles appear as a grainy texture when the negative or slide is greatly enlarged.

The three photographs to the right show the effects of film speed on graininess. Slow film is best for photographs in which great detail is required. Most photographers tolerate a certain amount of graininess in the final image when the situation requires a fast film. Since fast films need less exposure they can be used at higher shutter speeds to freeze action and can be used in lower light levels when slower film would require a tripod or flash.

ASA 32

ASA 400

ASA 1250

◀ For action scenes, particularly indoors, a fast film (ASA 400/ DIN 27 or higher) lets you use the fast shutter speeds needed to capture action sharply.

Donald Dietz

Processing and Printing Services

Processing labs will develop and print your pictures if you don't want to do so yourself.

Amateur-market labs deal mainly with snapshot developing and processing. When you take your film to a local store for processing, it is usually sent to one of these labs. Prices are generally low, but quality varies and consistently good printing is uncommon.

Custom or professional labs deal primarily with professional and serious amateur photographers, often by mail. Although the quality varies as widely as with amateur labs, many more of these labs do excellent work.

Manufacturers' labs—for example, those run by Kodak—usually have more consistent quality and a somewhat higher price than does an amateur-market lab. The range of services is smaller than in a professional lab.

Using trial and error to find a lab that meets your needs is a waste of time and money. Ask other local photographers, especially professionals, what lab they use and write directly to that lab for a complete list of their services and prices.

The services offered vary from lab to lab, but if you look around you can find all the following services:

Processing—developing the film either normally or with push processing that allows you to use the film at a higher-than-normal film speed rating.

Proofing—contact sheets (prints that are the same size as the negatives—usually one entire roll of film on an 8x10 sheet of paper) show the content and characteristics of the pictures so you can choose those from which you want to make enlarged prints.

Printing—either machine-made or individually printed.

Special services—cropping, burning, dodging, and other techniques to alter or improve the print.

Commonly Available Lab Services

Developing **Starting Point**	**Possibilities**	**Comments**
Undeveloped film: black-and-white or color	Processing, standard	Normal processing resulting in slides or negatives.
	Processing, push	Allows film to be shot at higher-than-normal film speed; data packed with film will indicate if feasible.

Prints **Starting Point**	**Possibilities**	**Comments**
Negatives: black-and-white or color	Machine prints	Generally the least expensive print. Made by a machine that automatically evaluates for density and color balance.
Negatives: black-and-white or color	Custom or individually made prints	Made by a human operator. Allows for services such as dodging, burning in, or cropping.
Negatives: color or Slides: color	Black-and-white prints	Black-and-white prints may be made from color negatives or slides but the quality may not be as good as a print made from a black-and-white negative.
Slides: color	Prints	The print is made directly from the slide (without using a negative).
Slides: black-and-white or color	Internegatives	The slide is enlarged onto negative film and the resulting negative is then used to make an enlarged print. Contrast can be controlled better than with a print made directly from a slide.
Slides: black-and-white or color	Duplicates	Cropping, plus some density and color balance correction, can be done in the duplicate.

Other Services	
Dodging	Lightening areas of the print that are too dark.
Burning in	Darkening areas of the print that are too light.
Cropping	Printing only part of the image area, usually to eliminate unnecessary elements at the edges.
Color correction	You can request that specific changes be made in the color balance of the print, or if you are uncertain, ask that the printer use his or her own judgment. Some labs will make a test strip to show you what's possible.

Testing Your Film Speed

If your photographs are consistently too light or too dark, you may obtain better results—such as richer colors in your slides—by using a film speed other than the manufacturer's recommendation. All films, but particularly color slide films, are very sensitive to slight variations in exposure. All automatic cameras use the film speed (ASA, DIN or ISO) that you enter into the film speed dial to compute the correct exposure when a picture is taken. Because of slight variations in shutter speeds and apertures from camera to camera the film speed designated by the film manufacturer may not be the ideal one for your specific equipment.

The test for film speed explained opposite is done by *bracketing*. Using the film speed dial on your camera to control exposure, a normal exposure is made, then several other pictures of the same scene are taken, first at higher film speed settings (giving less exposure to the scene), then at lower film speed settings (giving more exposure). This produces a range of pictures that will vary from dark to light. For a film speed test, you want to examine small differences in exposure, so changes are slight, 1/3 stop each time.

You can also use bracketing as a technique to make sure you get at least one good exposure when a picture is very important to you or when the lighting situation is unusual. When you bracket for this purpose, start with the normal or automatic exposure; under-expose one or two shots in half- or full-stop increments, then over-expose one or two shots in half- or full-stop increments. You can bracket by adjusting the film speed dial, as shown opposite, by using the exposure compensation dial if your camera has one, or by operating the camera manually.

The Film Speed Dial. *All of the ASA or DIN numbers cannot be listed on the film speed dial because of space limitations. This illustration shows how to read the marks between the numbers on the dial.*

Film Speed Scale													
DIN	27	26	25	24	23	22	21	20	19	18	17	16	15
ASA	400	320	250	200	160	125	100	80	64	50	40	32	25

Finding Your Personal Film Speed Step-by-Step

Film to Use. *Color reversal (slide) film is the most sensitive to slight exposure variations. For this test try a medium-speed film, ASA 50 to 100 (DIN 18 to 21).*

Subject to Use. *Well-illuminated, colorful, front-lit subjects are best for testing. You may want to include in each exposure a card marked with the appropriate film speed setting.*

The First Picture. *Set the film speed dial on the speed recommended by the manufacturer. (Here the recommended film speed is ASA 64/DIN19.)*

Taking the Pictures. *Using the table below, take three additional exposures at 1/3-stop decreases in film speed, for example, ASA 50, 40, and 32, by turning the film speed dial to each of those settings and taking the same picture. Then take another three at 1/3-stop increases in film speed,*

for example, 80, 100, 125. Log each frame number (from the frame counter dial) into the chart below with the film speed setting used if different from the example shown.

Arrange the Results. *Process the slides, arrange in order of their frame numbers, and label according to film speed. If you lose track of the numbering, simply label the darkest slide with the highest film speed, the next to darkest slide with the next to highest speed, and so on.*

Choose the Best Film Speed. *Project the slides as normally viewed and select the exposure you like best. Notice that the slides taken at lower film speeds may have brighter colors and more detailed shadow areas. Those taken at higher film speeds may have richer, more saturated colors. Use the film speed of your best exposure for other photographs taken under similar conditions.*

Film Speed Test Log

Frame Number	Test Sequence	ASA, DIN, or ISO Setting Used	
		Example	Actual
	Recommended speed	ASA 64	
	1/3 stop lower speed	50	
	2/3 stop lower speed	40	
	1 stop lower speed	32	
	1/3 stop higher speed	80	
	2/3 stop higher speed	100	
	1 stop higher speed	125	

What Went Wrong?

NO PICTURE AT ALL: SLIDES

Both Image Area and Edges Clear (Overexposed to light but not through the lens/shutter.)
> Camera back inadvertently opened (usually affects only part of the roll).

Image Area Clear but Edges Black, Except for Film Frame Numbers (Overexposed to light through the lens/shutter.)
> Wrong (much too low) film speed entered on camera's film speed dial.
> Aperture failed to stop down.
> Shutter sluggish or failed to close (especially in cold weather).
> Shutter was set at ''B.''

Both Image Area and Edges Black, Except for Film Frame Numbers (Film not exposed to light.)
> Unused film sent for processing.
> Flash failed to fire.
> Shutter accidentally released with lens cap left on.
> Shutter failed to open or mirror failed to move up.

NO PICTURE AT ALL: NEGATIVES

Both Image Area and Edges Black (Overexposed to light but not through the lens/shutter.)
> Camera back inadvertently opened (usually affects only part of the roll).

Image Area Black but Edges Clear, Except for Film Frame Numbers (Overexposed to light through the lens/shutter.)
> Wrong (much too low) film speed entered on camera's film speed dial.
> Aperture failed to stop down.

> Shutter sluggish or failed to close (especially in cold weather).
> Shutter was set at "B."

Both Image Area and Edges Clear, Except for Film Frame Numbers (Film not exposed to light.)
> Unused film sent for processing.
> Flash failed to fire.
> Shutter accidentally released with lens cap left on.
> Shutter failed to open or mirror failed to move up.

COMMON PROBLEMS WITH COLOR

Bluish Cast
> Overcast day.
> Tungsten film used in daylight.
> Marine or high altitude scene taken without use of UV filter.

Reddish-Orange Cast
> Daylight film used indoors in tungsten light.
> Sunset or sunrise scene.

Greenish Cast
> Film (particularly tungsten-balanced film) used with fluorescent illumination.

Weak Greenish or Reddish Cast, Sometimes Mottled
> Film outdated.
> Film stored where it's hot and humid.

Image Tinted by One Color
> Monochrome filter left on.
> Colored or reflected light illuminates subject.
> Incorrect processing.

Some Colors Correct, Others Way Off
> Uneven or mixed lighting.
> Color reflected by nearby objects on part of the subject.

What Went Wrong? (cont.)

COMMON PROBLEMS IN THE CAMERA

Double Exposure or Overlapping Exposures
> Film advance mechanism not working properly.
> Rewind button pressed inadvertently while winding the film.
> Double exposures on the first few frames and blanks everywhere else indicate that the film slipped off the transport sprockets and stopped advancing.

Unsharp or Fuzzy Pictures
> Camera movement.
> Shutter speed too slow for hand-held exposure.
> Camera not focused correctly.
> If moving subjects are fuzzy while other parts of the picture are sharp, the shutter speed is too slow to stop action.

Near Objects Sharp, Far Objects Blurred or Far Objects Sharp, Near Objects Blurred
> Insufficient depth of field.

Scratches Running the Length of Each Picture in the Same Place
> Dirt caught in the film canister scratching the film (scratches on front emulsion side or backing side of film).
> Dirt on the pressure plate (scratches on backing side of film).

Foggy Areas or Overall Fogginess
> Dirty or fingerprinted lens.
> Direct light on lens's front glass surface.
> Lens misted over with condensation from rapid temperature change.

Black Spots on Pictures
> Small fuzzy black spots in the same configuration on every frame indicate dust or lint inside the camera or on the front of the lens.
> Larger black areas are caused by fingers, camera strap, or other object immediately in front of the lens.

Vignetting (Dark Corners)
> Using a shade for a long-focal-length lens on a shorter lens.
> Using several filters or filter plus lens shade.

One Side of the Picture Is Dark
> If underexposed (dark but with some exposure): focal plane shutter not operating properly.
> If no exposure visible: flash used at a faster than recommended shutter speed.

"Lightning" Marks on the Picture
> Static electricity from advancing or winding the film too fast, especially in cold, dry weather.

Light Streaks or Spots Within the Image but Not by Sprocket Holes
> Direct light on lens's front glass surface.

Light Streaks Within Image and by Sprocket Holes
> If part of the film is blank (slides clear, negatives black) but most of it shows irregular light streaks: the back of the camera has been opened and the film exposed to the light.
> If irregular streaks appear on some frames: the film cassette has been handled in bright sunlight.

Dark Pictures
> Film speed set too high.
> Not enough light for proper metering and exposure.
> With aperture-priority operation, lens opening set too small.
> With shutter-priority operation, shutter speed set too fast.
> Very bright background.
> Too bright lights in some part of scene.

Light Pictures
> Film speed set too low.
> With aperture-priority operation, lens opening set too large.
> With shutter-priority operation, shutter speed set too low.
> Very dark background.

(See also pp. 138–139, Solving Flash Problems.)

6 Using Canon Lenses

John Littlewood

Getting to Know Your Lens

Modern lenses with coated surfaces are computer designed and far superior to lenses of only a few years ago. When choosing or using a lens, it helps to be familiar with the information on it that is provided by Canon because this information has a direct effect on the photographs you make.

Lens manufacturer

Lens coating, a chemical coating on the lens's glass surfaces, increases the transmission of light through the lens and reduces reflections that lower contrast and make colors less brilliant.

Canon's Spectra Coating (SC) is a single-layer coating that is as effective as ordinary multiple-layer coatings. A multiple-layer Super Spectra Coating (SSC) is applied to all Canon's newer lenses.

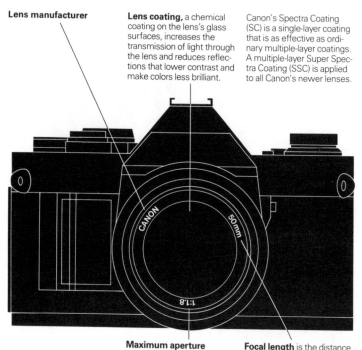

Maximum aperture (the lens's widest opening) is usually given as a ratio. 1:1.8 indicates that the lens's maximum aperture is the f-stop f/1.8. The smaller the numeral, the wider the lens opens. A "fast" lens, one with a very wide maximum aperture, is more expensive than a similar lens with a smaller maximum aperture, but it may be worth the premium if you often photograph in dim light.

Focal length is the distance in millimeters from the film plane to the lens's optical center. The smaller this numeral, the shorter the focal length of the lens. A short lens, also called a wide-angle lens, views a wide area. A long lens, often called a tele or telephoto, views a narrower angle and magnifies the subject more.

Your lens barrel has two rings that can be turned. One selects the aperture (lens opening) and the other focuses the image on the film plane. Engravings on the lens barrel that give focus and aperture information are easy to view when you are photographing. When the lens is inserted in the camera, the engravings lie on the top of the lens barrel with the numbers facing you.

The **focus ring** brings the image into focus on the film plane by moving the lens elements nearer to or farther from the film.

The **distance scale** rotates as the lens is focused. When lined up with a centrally located focus index, it tells the distance at which the lens is most sharply focused.

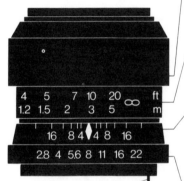

The **depth-of-field scale** indicates how much of the scene will be sharp for any given aperture. Any distance (on the distance scale) falling between a pair of aperture numbers on the depth-of-field scale will be acceptably sharp for normal prints, if you shoot at that aperture.

A **meter coupling lug** connects the lens to the camera's automatic exposure system. All lenses designated FD are fully automatic: you view and meter the light with the lens wide open, and it will automatically stop down to the correct aperture when the exposure is made. An FL lens allows full aperture viewing, but requires stopped-down metering; that is, it is manually stopped down to the shooting aperture during metering.

The **aperture control** can be turned to open up (increase) or stop down (decrease) the lens opening. The smallest opening has the highest f-stop numeral (for example, f/22); the largest opening has the smallest (for example, f/2). The normal series (no lens has all of them) is 1, 1.4, 2, 2.8, 4, 5.6, 8, 11, 16, 22, 32, and 45. Each f-stop lets in half as much light as the preceding one and twice as much as the one that follows.

Lens Focal Length

The basic difference between lenses is in focal length. The longer the focal length of the lens (usually measured in millimeters, mm), the more it will enlarge an object and the narrower its angle of view, that is, the less it will show of a given scene. (See illustrations below and opposite.) A short-focal-length (also called wide angle) lens is shorter than 50mm and is useful when you want to show a wide view of a scene or when you are photographing in close quarters, for example, on a boat. A long-focal-length (also called telephoto) lens is longer than 50mm and is useful for enlarged views of part of a scene or of objects at a distance. Most cameras are sold with a 50mm, normal-focal-length lens which produces an image somewhat similar to that seen by the human eye. A zoom lens combines a range of focal lengths within one lens, such as 35–70mm; its focal length is adjustable so that you can shoot at any focal length within that range.

A fast lens, one that opens to a wide maximum aperture, may be important if you often photograph in dim light or at fast shutter speeds (see pp. 97 and 117).

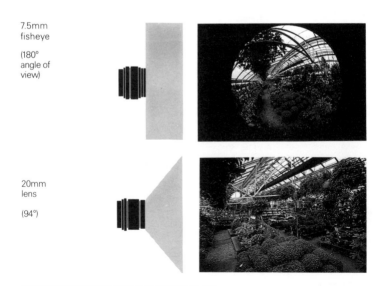

7.5mm
fisheye

(180°
angle of
view)

20mm
lens

(94°)

35mm
lens

(63°)

50mm
lens

(46°)

100mm
lens

(24°)

200mm
lens

(12°)

400mm
lens

(6°)

Alan Oransky

Normal and Short-Focal-Length Lenses

NORMAL LENSES

A normal lens for a 35mm camera has a focal length of approximately 50mm. It produces an image that appears similar to the way the human eye and brain perceive a scene. Objects do not appear distorted in very deep space, as they sometimes do with a wide-angle lens. Nor do they appear compressed and very close together as they can with a telephoto lens. Unless otherwise requested, a 50mm lens usually comes with the camera when you buy it. Produced in large numbers and relatively simple in design, these are the least expensive focal-length lenses.

Joe Wrinn

A normal lens typically has a relatively large maximum aperture. This makes it useful for photographing in dim light.

Canon Lens	Angle of View	Minimum Aperture	Filter Diameter
FD 50mm f/1.2 L	46°	f/16	52mm
FD 50mm f/1.4	46°	f/22	55mm
FD 50mm f/1.8	46°	f/16	55mm
FD 55mm f/1.2 SSC	43°	f/16	58mm

L = improved optics. SSC = Super-Spectra multicoating.

WIDE-ANGLE LENSES

Wide-angle lenses (35mm or less) have a shorter focal length than does a normal lens and are a favorite of many photographers. Wide-angle lenses have great depth of field, so that both near and far objects are sharp. Often you can photograph action without having to refocus every shot because the entire area that you are working with will be sharp. They also have a very wide angle of view so that you can photograph in confined areas, like an automobile (below), a small room, or in a crowd of people from a short camera-to-subject distance.

Joe DeMaio

Wide-angle lenses have much greater depth of field than do lenses with longer focal lengths; this allows them to be used close to subjects while still maintaining a reasonable depth of field to keep subjects at varying distances sharp in the image.

Canon Lens	Angle of View	Minimum Aperture	Filter Diameter
FD 17mm f/4	104°	f/22	72mm
FD 20mm f/2.8	94°	f/22	72mm
FD 24mm f/1.4 L	84°	f/16	72mm
FD 24mm f/2	84°	f/22	52mm
FD 24mm f/2.8	84°	f/16	55mm
FD 28mm f/2	75°	f/22	55mm
FD 28mm f/2.8	75°	f/22	55mm
FD 35mm f/2	63°	f/22	55mm
FD 35mm f/2.8	63°	f/22	52mm

L = improved optics.

Long-Focal-Length and Zoom Lenses

LONG LENSES

Lenses of longer than normal focal length are ideal when you cannot get close to a subject and must shoot from a distance. The longer the focal length, the more the image is magnified and the narrower the angle of view the lens takes in. In effect, this magnifying power of the lens enlarges the subject without your having to move in close.

Kim Allis

A long-focal-length lens seems to compress space so that these polo players appear to be closer together than they really are.

Canon Lens	Angle of View	Minimum Aperture	Filter Diameter
FD 85mm f/1.2 L	28°30′	f/16	72mm
FD 85mm f/1.8	28°30′	f/16	55mm
FD 100mm f/2	24°	f/16	52mm
FD 100mm f/2.8	24°	f/22	55mm
FD 135mm f/2	18°	f/32	72mm
FD 135mm f/2.8	18°	f/22	58mm
FD 135mm f/3.5	18°	f/22	55mm
FD 200mm f/2.8	12°	f/22	72mm
FD 200mm f/4	12°	f/22	55mm
FD 300mm f/2.8 L	8°15′	f/22	48mm insertion type
FD 300mm f/4	8°15′	f/22	34mm
FD 300mm f/4 L	8°15′	f/22	34mm insertion type
FD 300mm f/5.6	8°15′	f/22	55mm
FD 400mm f/4.5 SSC	6°10′	f/22	34mm insertion type
FD 500mm f/4.5 L	5°	f/32	48mm insertion type
FD 500mm f/8	5°	f/8	34mm insertion type
FD 600mm f/4.5	4°10′	f/22	48mm insertion type
FD 800mm f/5.6 L	3°06′	f/22	48mm insertion type
FL 1200mm f/11	2°05′	f/64	48mm insertion type

L = improved optics. SSC = Super-Spectra multicoating.

ZOOM LENSES

Zoom lenses are designed so that focal length can be changed by sliding a collar on the lens barrel. This gives you an infinite selection of focal lengths within the designated range; for example, with an 80-200mm zoom you can shoot at 80, 90, 100, or 200mm or any focal length in between. The convenience of carrying one lens instead of a bagful makes the zoom lens very popular.

Elizabeth Hamlin

The zoom lens not only allows you to change focal lengths without changing lenses but also can be zoomed during the exposure for unusual effects.

Canon Lens	Angle of View	Minimum Aperture	Filter Diameter
FD 24–35mm f/3.5 L	84°–63°	f/22	72mm
FD 28–50mm f/3.5	75°–46°	f/22	58mm
FD 35–70mm f/2.8–3.5	63°–34°	f/22	58mm
FD 35–70mm f/4	63°–34°	f/22	52mm
FD 35–105mm f/3.5 with macro	63°–21°	f/22	72mm
FD 70–150mm f/4.5	34°–16°20′	f/32	52mm
FD 70–210mm f/4	34°–11°	f/32	58mm
FD 80–200mm f/4	30°–12°	f/32	55mm
FD 85–300mm f/4.5	28°30′–8°15′	f/32	Series IX
FD 100–200mm f/5.6	24°–12°	f/22	55mm
FD 100–300mm f/5.6	24°–8°15′	f/32	58mm

L = improved optics.

Fisheye and Macro Lenses

FISHEYE LENSES

Fisheye lenses have an extremely short focal length (as short as 7.5mm) and an extremely wide angle of view (180°). Their depth of field is enormous; everything is sharp from objects within a few inches of the lens to the farthest visible horizon.

Fisheye lenses bend straight lines into curves, particularly at the edges of the picture, and can produce unusual and startling effects. Canon's 15mm fisheye fills the rectangular film format, the 7.5mm fisheye produces a round image in the center of the film (like the picture here).

Elizabeth Hamlin

The fisheye lens has a very wide angle of view, which offers many creative opportunities. It also greatly distorts the subjects in an image.

Canon Lens	Angle of View	Minimum Aperture	Filter Diameter
Fisheye 7.5mm f/5.6	180°	f/22	Built-in
Fisheye FD 15mm f/2.8	180°	f/16	Built-in

MACRO LENSES

Macro lenses can be focused very close to a subject; the closer you are, the larger the image on your film. A normal 50mm lens focuses no closer than about 18 inches to a subject, but a 55mm macro lens, without any special attachments, focuses as close as 9.5 inches, producing a significant increase in image size. More about close-up photography in Chapter 9.

Macro lenses are specially designed to perform well at very close focusing distances, but they also do a good job at normal distances so they can be used for photographs that are not close-ups.

Fredrik D. Bodin

The close focusing ability of the macro lens allows you to get very close to objects. The lens can also be used for general photography.

Canon Lens	Angle of View	Minimum Aperture	Filter Diameter
50mm f/3.5 macro with			
Extension Tube FD 25	46°	f/22	55mm
FD 100mm f/4 SC macro with			
Extension Tube FD 50	24°	f/32	55mm
FD 200mm f/4 macro	12°	f/32	58mm

Lens Extenders

A Canon lens extender attached between a lens and the camera will increase the focal length of the lens. Small and easy to carry, a lens extender is usually less costly than a new lens. High quality is essential in an extender because you are in effect adding an optical element to the lens when you use one. Canon extenders are corrected for field curvature and other aberrations present in many extenders, and according to Canon engineers there is virtually no difference in optical quality with or without the extender.

Canon makes three extenders. Extender FD 1.4X-A works with all FD lenses having a fixed focal length of 300mm or longer. It increases focal length by 1.4X, for example converting a 400mm lens into a 560mm lens (see opposite). Extender FD 2X-A doubles the focal length of the lens to which it is attached (see opposite) and is suitable for use with all FD lenses of 300mm focal length or longer, including zooms. Extender FD 2X-B is similar to the FD 2X-A, but is used with lenses of 300mm focal length or shorter. Automatic exposure functions are maintained with these extenders.

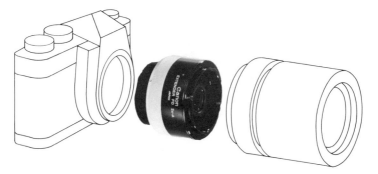

A lens extender mounted between the camera body and lens increases the effective focal length of the lens (see illustrations opposite). Your camera continues to function automatically when a Canon extender is used.

400mm lens

50mm lens

400mm lens plus 1.4X extender

50mm lens plus 2X extender

Fredrik D. Bodin

Perspective: Depth in a Photograph

Why do some photographs seem to distort a subject so that, for example, a man's head appears to be miles away from his feet (right) or dozens of trailers appear to be crammed into an impossibly small space (below)? Perspective (the sizes of objects and their apparent positions in space) changes—even to the point of grotesque distortion—when the distance from the lens to the subject changes. The closer an object is to the lens, the larger its image will be. The brain judges depth in a photograph mainly by comparing relative sizes. A scene can look stretched out if the lens exaggerates the size of an object by being much closer to it than it is to other objects. A scene can look squeezed together if the lens minimizes size differences by being relatively far from all the objects.

Peggy Cole

Perspective—the relative size and depth of objects—can be exaggerated. Stretch a subject out (above) by photographing very close to one part of it with a short-focal-length lens that can be focused up very close. Squeeze a scene together (below) by photographing far from all the objects in it with a long-focal-length lens.

Fredrik D. Bodin

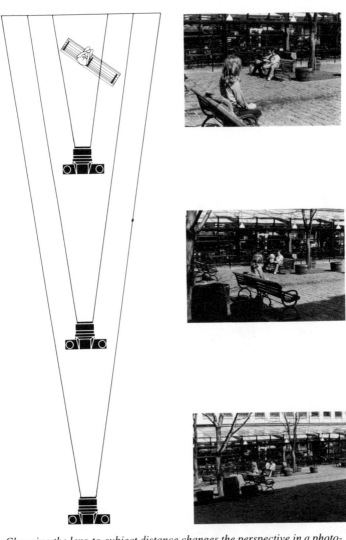

Barbara M. Marshall

Changing the lens-to-subject distance changes the perspective in a photograph. As the camera was brought nearer to the subject, the woman in the foreground appeared to increase in size relative to the couple in the background. As a result the impression of depth increased between the foreground and background. Changes in perspective like these are exaggerated by using a short-focal-length lens and moving nearer to the subject (opposite, top), or by using a long-focal-length lens and moving back (opposite, bottom). Perspective does not change at all if you simply change the focal length of your lens without moving nearer or farther.

7 Filters and Lens Attachments

George Cannon

Filters for All Films

Filters and lens attachments are valuable tools for getting better pictures. Image contrast, color, and various special effects can be controlled by these accessories, which alter or limit light entering the lens. They can make a photograph more realistic or can change an image from what it would normally be.

Many filters work by removing part of the light spectrum entering the lens. To make up for the eliminated light, exposure usually must be increased, either through the automatic system or manually. Certain filters, such as a red one, require a relatively large amount of exposure increase (up to 3 stops), which could make them inconvenient to use in dim light or when a small aperture or fast shutter speed is important (see pp. 124–125).

How a Filter Works. *Ordinarily when you focus your camera on a scene, the lens gathers and focuses the entire light spectrum reflected to the camera. A filter in front of the lens blocks part of this light or otherwise changes its quality.*

Colored filters *absorb certain wavelengths or colors of light and pass the rest to the lens. With color film the result is a change in the color balance of the picture; with black-and-white film the result is a change in the lightness or darkness of objects of certain colors. (See pp. 118–121.)*

Neutral density filters *absorb all colors of light equally, reducing the light reaching the film, but leaving the color balance unchanged. They are useful if you want a slower shutter speed or larger aperture than you can obtain with the speed of the film in your camera.*

Polarizing filters *block only certain light, such as reflections from glass or water. (See opposite.)*

Special effects attachments *don't usually absorb light but rather redirect part of it to make unusual patterns on the film. (See pp. 124–125.)*

Without Polarizing Filter

With Polarizing Filter

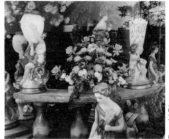

Donald Dietz

A polarizing filter can be used to decrease reflections from glass (as shown here), water, or other nonmetallic surfaces. The filter is placed on the lens, then rotated for the desired effect. It works best when the camera is at an angle of 30–40° from the reflecting surface.

David A. Morrison

A polarizing filter will also darken skies and make distant details clearer and brighter in a landscape by decreasing reflections of light from particles of water or dust in the atmosphere. For this use, the filter works best when used at a 90° angle to the sun's rays.

Filters for Black-and-White Film

Black-and-white film records colors in various shades of gray. If certain colors of light are absorbed by a filter, objects of those colors will appear darker in the final photograph. For example, a deep yellow filter attached to a lens will absorb part of the blue light from the sky, causing the sky to appear darker (see below).

A yellow, orange, or red filter used with black-and-white film will make a blue sky appear darker in a photograph. The yellow filter will darken the sky to a normal tone, orange will make it darker than normal, and red will make it appear very dark, sometimes almost black. These filters also can reduce bluish haze in distant landscapes. They do not significantly darken a foggy or overcast sky that is gray rather than blue.

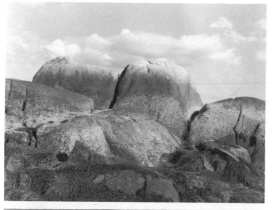

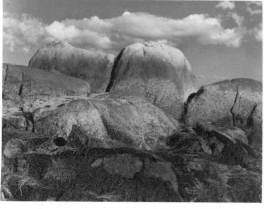

Sam Laundon

Objects such as red flowers and green leaves that are clearly of different colors in nature or on color film may record as the same tone on black-and-white film. A filter can be used to lighten or darken one of the objects. Above left, tones of green leaves and a red rose are very close when no filter was used. Above right, the same scene with a red filter. Left, a green filter was used.

Sam Laundon

Filters for Black-and-White Film

Situation	Effect on Photograph	Filter
Sky	Darken blue sky, reduce bluish haze	
	Normal sky tone	yellow 2
	Darken sky more	deep yellow or orange 15
	Very dark sky	red 25A
		May be used in combination with polarizing filter
Marine scenes	Darken blue water (works if sky is blue)	Any of the above filters
Landscapes	Increase effect of bluish haze	blue
Reflections	Reduce reflections	polarizing
Changing contrast	Lighten reds, as in flowers	red
	Lighten greens, as in foliage	green
	Lighten blues, as in flowers	blue

Filters for Color Film

Color film is designed to give a natural effect when used in light of a certain color balance: tungsten-balanced film is intended for use in tungsten light, daylight-balanced film in daylight or with flash (see pp. 84–85). If you use color film, any filter that changes the color balance of the light entering the camera will have an effect on colors in the photograph. Using a red filter, for instance, will give a picture an overall red cast.

The main use of filters with color film is to change the color balance of the light to match the color balance of the film more closely so that the final photograph appears natural and pleasing. Filters remove the blue cast from pictures taken in open shade or on the snow, absorb excessive ultraviolet light at high elevations, allow tungsten-balanced film to be used outdoors, and allow daylight-balanced film to be used in tungsten light (because of the exposure increase required this may not actually be practical, see pp. 122–123).

Eric Myrvaagnes

Snow scenes photographed in color can look too blue, particularly in shadow areas or if the light comes from an overcast sky. A 1A skylight or UV (ultraviolet) haze filter will reduce the excess blue considerably.

Hillary Liss

Marine scenes in color can take on an overall blue cast from the bluish reflections of water and sky. A 1A skylight or UV (ultraviolet) haze filter will return the scene to a more neutral overall rendering.

Filters for Color Film

Situation	Effect on Photograph	Filter
Marine, snow, or aerial scenes, overcast day, open shade	Reduce blue cast Reduce blue cast more	1A skylight or UV (ultraviolet) haze light yellow 81A
Early morning, late afternoon	Reduce orange-red cast	light blue
Skies	Darken	polarizing
Daylight film used in tungsten light	Remove orange-red cast	80 blue
Tungsten film used in daylight	Remove blue cast	85 amber
Daylight film used in fluorescent light	Reduce green cast	FCD fluorescent
Tungsten film used in fluorescent light	Reduce green cast	FCB fluorescent
Reflections	Reduce reflections	polarizing

Using Canon Filters

Many filters work by removing certain wavelengths of light. The purpose is usually to change the color balance of the light, but a secondary effect is to decrease the brightness of the light that strikes the film. To avoid underexposing the film, the overall exposure must be increased, by using either a wider aperture or a slower shutter speed. With automatic exposure, your camera meters the light after it has passed through the filter and lens and so automatically compensates for any change in brightness; you don't have to adjust the camera settings manually. But it is useful to know that an exposure increase will take place with some filters (see chart opposite), especially when used with a slow film or when high shutter speeds and/or great depth of field are required. The increase in exposure may slow your shutter speed or open your aperture so much that it gives you more blur from camera or subject motion or less depth of field than you want. If you use a filter when taking a flash photograph, open the lens aperture the amount shown in the chart.

Filter	Lens Diameter Sizes (in mm)	Effect	Exposure Increase
Haze (UV–1)	43, 48, 49, 52, 55, 58, 72	Eliminates ultraviolet radiation that film records as haze or excess blue in mountain, snow, marine, or aerial scenes.	None
Sky 1A (Skylight)	43, 48, 49, 52, 55, 58, 72	Similar to Haze (UV-1).	None
Yellow 2	48, 49, 52, 55, 58, 72	With b&w film, darkens blue sky to bring out clouds.	Daylight 1 stop Tungsten ⅔ stop
Green 11	48, 49, 52, 55, 58, 72	With b&w film, lightens foliage and darkens sky; for outdoor portraits, darkens sky without making skin tones pale.	Daylight 2 stops Tungsten 1⅔ stops
Orange 15	48, 49, 52, 55, 58, 72	Stronger than Yellow 2.	Daylight 1⅔ stops Tungsten 1 stop

Filter	Lens Diameter Sizes (in mm)	Effect	Exposure Increase
Red 25A	48, 49, 52, 55, 58, 72	Stronger effect than Orange 15 filter. Used with infrared film.	Daylight 3 stops Tungsten 2⅔ stops
80A (blue)	49, 52, 55, 58, 72	Corrects color balance when daylight film used indoors with tungsten lights.	2 stops
80B (blue)	49, 52, 55, 58, 72	Corrects color balance when daylight film used indoors with 3400K tungsten lights.	1⅔ stops
81A (light yellow)	49, 52, 55, 58, 72	Slight warming effect with color film. Reduces excess blue when daylight film used with electronic flash or in open shade.	⅓ stop
81B (light yellow)	49, 52, 55, 58, 72	Stronger than 81A.	⅓ stop
85 (amber)	49, 52, 55, 58, 72	Corrects color balance when Type A indoor color film used outdoors.	⅔ stop
85B (amber)	49, 52, 55, 58, 72	Corrects color balance when tungsten-balanced color film used outdoors.	⅔ stop
0.3ND	49, 52, 55, 58, 72	Increases amount of exposure needed without changing color or tonal values.	1 stop
0.6ND	49, 52, 55, 58, 72	Increases amount of exposure needed twice as much as 0.3ND filter.	2 stops
Polarizer	48, 49, 52, 55, 58, 72	Reduces reflections and unwanted glare.	2 stops
FCB (fluorescent)	49, 52, 55, 58, 72	Improves color balance when tungsten-balanced film used with fluorescent lighting.	1 stop
FCD (fluorescent)	49, 52, 55, 58, 72	Improves color balance when daylight film used with fluorescent lighting.	1 stop
Softmat No. 1	48, 52, 55, 58	Creates foggy, misty effect.	—
Softmat No. 2	48, 52, 55, 58	Stronger than Softmat No. 1.	—

Lens Attachments for Special Effects

In addition to using filters that change the overall contrast or color balance of a photograph, you can also use lens attachments in front of your lens to create unusual effects. These special-effect attachments can make lights appear as stars with radiating points, break the image into repeating patterns, achieve extreme depth of field, or change the color of one part of the photograph without affecting other parts. You can even create the soft focus effect used by some portrait and glamour photographers. Some of the more popular special effect attachments are illustrated and described below.

Without Attachment **With Attachment**

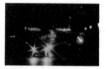

Cross Screen (four-ray, six-ray, eight-ray)
Each point source—a point of bright light or bright reflection—radiates rays of light.

Spectra (4X, 8X)
Each point source of light radiates starlike beams in three spectral colors. Especially visible in night scenes.

Soft Focus
Softens details and can make bright highlights shimmer and gleam.

	Without Attachment	**With Attachment**

Spot Lens
A sharp central field becoming progressively hazy at the edges. For emphasizing details of a subject.

Prism (triangular)
Triangular prisms without a central image.

Prism (parallel)
Multiple prism with three parallel fields. Reproduces the subject side by side, tilted, or one above the other.

 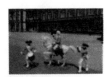 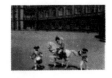

Split Field or Bifo
Part of the filter surface is a close-up lens and the rest is clear glass. Thus objects at close range (approximately 24 cm or 10 inches) and those far away can be focused sharply at the same time.

8 Using Canon Electronic Flash

segmentnavigation">127

Flash Characteristics
Canon Electronic Flash
Equipment
Determining Flash Exposures

Better Flash Portraits
Flash in Outdoor Portraits
Solving Flash Problems

Colleen Chartier

Flash Characteristics

An automatic flash unit makes flash photography easy. Within the range of distances that the unit covers, you just focus and shoot. A photoelectric sensor regulates the length of the flash for exposure. All the units listed on p. 131 are automatic.

All the Canon flash units listed are also "dedicated" units. They electronically set any "A" series camera to the correct shutter speed for synchronization with flash. In addition, they automatically set the aperture when used with the A-1, AE-1, or AE-1 Program. They can be used with the F-1 (with accessory flash coupler F) as well as with other single-lens reflex cameras. When Speedlite 188A is used with the AE-1 Program, a signal in the camera's viewfinder shows when the unit is fully charged and then flashes to confirm proper exposure after firing.

The guide number for a flash unit is a way of judging its power. The higher the guide number, the brighter the flash and the greater the distance you can use it from a subject. A wide-angle adapter, which increases the angle of illumination of the flash, cuts the guide number somewhat. A tele adapter, which narrows the beam of light, increases the guide number.

Aperture choices with flash increase the range of distances within which you can use the flash in its automatic mode. The choice of apertures also can be useful if you want to control depth of field in a particular shot.

Flash interval, the length of time it takes to recharge after firing, can be important if you want to take shots in quick succession.

Auto bounce capability gives you the option of maintaining automatic operation while tilting the head of the flash upward instead of pointing it directly at the subject.

Angle of illumination. All Canon flash units will fully light an area as wide as that photographed by a lens of 35mm focal length. But if you want to use a lens of shorter focal length (and so, wider angle) a wide adapter is supplied with several of the units which will broaden the light from the flash.

Energy-saving circuitry recycles unused energy in automatic operation instead of discharging it as ordinary circuitry does. The results are shorter recycling times and longer battery life.

Fredrik D. Bodin

When your flash is fired, the beam of light expands as it moves farther from the camera. As a result, subjects near the flash will be illuminated with a more intense light (and will be lighter in the picture) than subjects farther away (which will be darker). Above, the flash was set to properly expose the musicians in the front. Because light from the flash got dimmer the farther it traveled from the flash, the musicians in the back are darker the farther they are from the flash.

The light emitted by a flash is very brief, 1/1000 sec or less, and will stop most action, like the juggler's act, below left. Below right: the photographer left the shutter open for several seconds to record the light patterns of the boy's sparkler, then fired a flash to illuminate the boy.

Colleen Chartier

Ron Carraher

Canon Electronic Flash Equipment

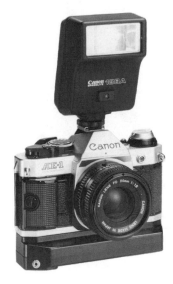

Canon makes several compact and lightweight electronic flash units that mount on the hot shoe on top of the camera's pentaprism. Speedlite 188A is shown here on the AE-1 Program camera. Speedlites 133A, 155A, 177A, and 199A are similar.

Canon also makes two powerful handle-mounted flash units, the Speedlite 533G (shown here on the A-1 camera) and the Speedlite 577G. These units use a separate sensor on the camera's hot shoe while the flash attaches to a quick release bracket.

Canon's electronic flash units are summarized in this chart. For an expla- ▶
nation of flash features, such as guide number, see p. 128.

Speedlite Model	133A	155A	177A	188A	199A	533G	577G
Guide Number with ASA 100 Film and Distance in Feet (In Meters)	53 (16)	56 (17)	82 (25)	82 (25)	98 (30)	118 (36)	157 (48)
Auto Aperture Choices	1	2	2	2	3	3	3
Auto Working Range (without adapters)	2–26 ft (0.5–8m)	2–20 ft (0.5–6m)	2–29 ft (0.5–9m)	2–29 ft (0.5–9m)	2–35 ft (0.5–10.6m)	3.3–42 ft (1–12.8m)	3.3–56 ft (1–17m)
Flash Interval (sec)*							
Alkaline Batteries	9	7	8	8	10	10	18
Ni-Cd Batteries	6	5	6	6	6	5.5	7
Auto Bounce Capability	—	—	—	—	with adjustable head	with separate sensor	with separate sensor
Angle of Illumination Gives Full Coverage with:	35mm lens	35mm lens	35mm lens; 28mm with adapter	35mm lens; 28mm with adapter	35mm lens; 24mm with adapter	35mm lens; 24mm or 20mm with adapters. Tele adapter available.	35mm lens; 24mm or 20mm with adapters. Tele adapter available.
Energy-Saving Circuitry	yes	yes	yes	yes	yes	yes	yes

* Depending on power source and/or subject distance

Determining Flash Exposures

Using an automatic flash is easy. Once the camera and flash controls are set, all you have to do is make sure the subject stays within the range of distances suitable for your unit. The flash's automatic sensor cuts off the flash when exposure is correct.

A dedicated flash (any Canon flash used with an A Series camera) will automatically set the camera to the correct synch shutter speed. If your flash isn't dedicated, see your owner's manual for correct shutter speed. You then set the lens aperture depending on the power of your unit and the film speed you are using. With some flash/camera combinations, the aperture is also set automatically (see p. 128).

Some units work on automatic at only one aperture with any given film speed. Other flash units offer automatic operation at a range of working apertures. With these, you set the lens to one aperture, perhaps f/2.8, for distant subjects, then to f/5.6 for those that are nearby. Usually, the more powerful a unit is, the greater the range of distances at which it works automatically and the more choices you have in aperture settings. The chart on p. 131 gives more information.

How the Auto Sensor Works

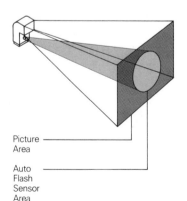

Picture Area

Auto Flash Sensor Area

The sensing cell that controls automatic flash operation reads only a portion of the scene you are photographing. If your main subject is at the very edge of the flash's illumination, it may not be metered properly. When possible, try to have the subject more or less in the central portion of the scene.

USING YOUR FLASH ON MANUAL

When set on manual, your flash's automatic circuitry is discon-
nected and the flash no longer automatically terminates when
sufficient light has been emitted. Exposure is controlled by setting
the aperture according to the distance between your subject and
the flash. To determine exposure in manual operation with the flash
calculator dial:

1. Enter the film speed into the
flash unit's film speed dial.
Set the camera's shutter to the
correct speed for flash.
2. Focus the camera on the
subject and read its distance on
the lens's distance scale.
3. Set lens with aperture rec-
ommended (on the flash unit's
calculator dial) for that dis-
tance. When outdoors at night
or in a very large room, you
may need to open the lens ap-
erture 1 stop wider than the
recommended setting.

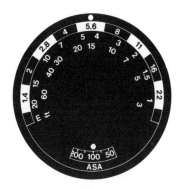

*This costumed apparition was photographed with automatic flash. If the
subject is in the center of the photograph, as here, a flash's automatic
sensor is more likely to give an accurate reading than if the subject is off to
one side.*

Better Flash Portraits

Flash is convenient to use for indoor portraits. Because the flash of light is much faster than the slower shutter speeds you would have to use in dim interior light, your sitter doesn't have to hold still during the exposure. You can shoot whenever you see an expression you like.

All Canon A Series cameras are equipped with a hot shoe into which a camera-mounted flash can be slipped (flash can be mounted on an F-1 camera by means of an accessory flash adapter). The hot shoe or coupler supports the flash on top of the camera and connects it electrically to the camera's controls. Some flash units are rigid and always fire straight ahead so that the flash illuminates the subject directly from camera position. Some units allow the flash head to be tilted so that, if you wish, the light can be bounced onto the subject from a reflecting surface like a ceiling. Most cameras have an outlet for an extension synch (pronounced *sink*) cord that runs between the flash and the camera and lets you use a flash away from its hot shoe connection.

Sometimes a subject's eyes appear red in a color photograph made with flash. This "red-eye" effect is caused by the flash reflecting off the subject's retina. To prevent it (and minimize reflections from eyeglasses), use off-camera or bounce flash, or tell the subject not to look directly at the camera lens.

Flash on Camera. *With the flash mounted on the camera's hot shoe the subject is illuminated directly from camera position. The subject has typical flash-on-camera lighting: thin-edged shadows with volumes and textures flattened out.*

Direct Flash Off-Camera. *Direct flash off-camera using an extension synch cord casts light directly onto the subject from the side and gives more modeling and texture because facial shadows are more prominent. To avoid a shadow on the wall, move the subject away from it or raise the flash more.*

 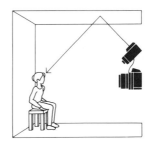

Flash Bounced from Ceiling. *Flash bounced from the ceiling lights the subject with a soft and natural light. To do this with automatic exposure, the flash head must swivel while the sensor cell remains pointed at the subject. If your flash does not do this, set the flash to manual and calculate the exposure based on the distance from flash to reflecting surface to subject. Open the lens aperture about 1 stop more than the one indicated on the calculator to allow for light absorbed by the ceiling.*

 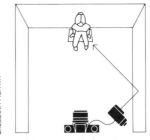

Elizabeth Hamlin

Flash Bounced from Wall. *Flash bounced from a wall also gives a soft, even light, more attractive than ceiling bounce because no dark shadows appear in the eye sockets. To avoid a shadow on the back wall, move the subject away from it. Calculate exposure as for ceiling bounce.*

Flash in Outdoor Portraits

Many photographers think of flash as something to be used indoors only when there isn't enough light to take a picture without it. Actually, flash can be used outdoors to get better portraits in bright sunlight. To avoid taking portraits of people squinting at the sun, let the sun sidelight your subject while the flash lightens the dark shadows that would otherwise appear on the side of the face away from the sunlight.

With the subject facing the sun, the face is well illuminated, but the bright sun shining in the subject's eyes causes an unattractive squint.

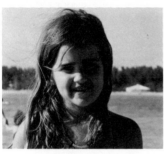

Here the subject has been illuminated only by sidelight from the sun. The squint is gone, but the side of the face in shadow is very dark. It is dark in this picture and would be even darker in a slide. Simply increasing the exposure wouldn't work because the lit side of the face would then be too light.

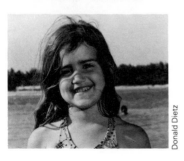

Here the photographer added fill light from a flash mounted on the camera's hot shoe to lighten the shadowed side of the face but still keep it somewhat darker than the lit side. Instead of a flash, you could also use light reflected from a light-colored card or cloth.

Donald Dietz

HOW TO DETERMINE FILL-FLASH EXPOSURES

When using fill flash outdoors, first set your camera's shutter speed and aperture for an ordinary exposure without flash. You can control the amount of flash light falling on the subject and so the darkness of the shadow area by moving the flash closer to or farther from the subject.

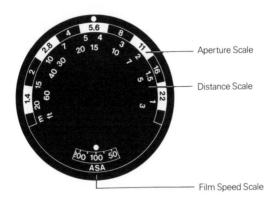

Aperture Scale

Distance Scale

Film Speed Scale

1. *Set your flash on manual mode.*
2. *Set your camera to the correct shutter speed setting for flash (see your owner's manual).*
3. *Select an aperture that will give you a good daylight exposure for the overall scene as if you were not using flash.*
4. *Find the aperture you are using on the flash unit's calculator dial. The distance opposite that f-stop is the distance at which to stand for a 1:1 lighting ratio (the flash will lighten the shadow side of the face to be the same brightness as the sunlit side). If you lighten the shadow this much, the picture will probably look unnatural—the shadow will be too light.*

To obtain a light, but visible, shadow, good for color slide film:
Move back 1½ times the distance indicated by the calculator dial. For example, if the dial indicates 10 feet, stand about 15 feet away. A simpler option (and one that will put you at more reasonable shooting distance) is to stand at the distance suggested by the dial but reduce the light emitted by the flash by draping a white handkerchief over the flash head.

To obtain a darker shadow, good for black-and-white film:
Move back about 2 times the distance indicated by the dial. For example, if the dial indicates 10 feet, move back 20 feet from the subject. Or, instead, drape two layers of handkerchief over the flash.

Solving Flash Problems

Flash photography usually gives good results because the light is consistent and automatic flash units make it easy to get a good exposure. Things can go wrong, however, and this guide should help you identify your problem.

Fredrik D. Bodin

Wrong Synch Speed. *If part of the frame is completely black and unexposed, the camera's shutter speed was too fast to synchronize with the flash.*

Solution: *Refer to your owner's manual to determine how to set your camera for flash operation.*

Fredrik D. Bodin

Harsh Shadows Behind Subject. *If hard-edged dark shadows are visible on the wall behind your subject, you are probably using direct flash off-camera.*

Solutions: *Move the subject farther from the wall. Use bounce flash for more even lighting. With direct off-camera flash, move the flash higher to cast the shadow outside the picture area.*

Fredrik D. Bodin

Overexposure. *If subject appears too light, the picture is overexposed.*

Solutions: *Do not get closer to the subject than the minimum flash range. Make sure you use a recommended aperture for your flash. Make sure your subject occupies the central portion of the picture so the flash sensing cell measures the right part of the scene. Some automatic flash units overexpose the subject if the background is a dark sky at night or is too far away for light to reach it. See your owner's manual.*

Fredrik D. Bodin

Underexposure. *Subject is underexposed and too dark.*

Solutions: *Make sure subject is within maximum operating range of the flash. Make sure you have used the correct aperture for your flash.*

Fredrik D. Bodin

Visible Reflections. *If your picture has glare spots from glass or other shiny surfaces, the flash and camera are facing directly toward the reflecting surface.*

Solution: *Stand at an angle to the surface.*

9 Close-up and Still Life Photography

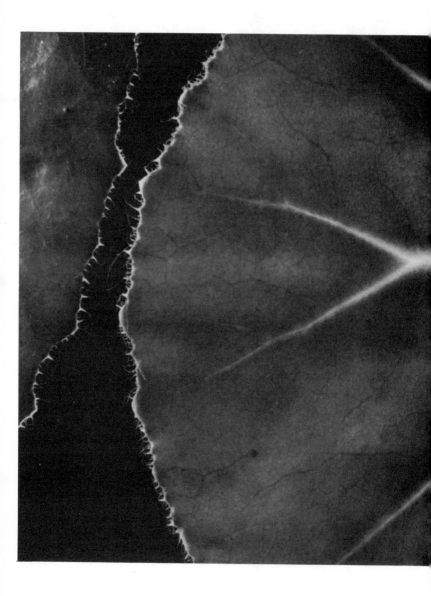

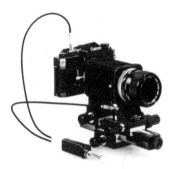

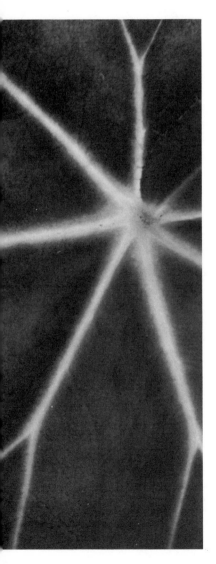

Canon Close-up Equipment

One of the fascinating aspects of making close-up photographs is that such common objects—a leaf, a flower, an ordinary vegetable—look so much more interesting when seen close up. To get a greatly enlarged image of an object on film, you need to use your camera closer than normal to the subject, but most lenses are not designed to let you work at very close focusing distances. The close-up equipment shown either adapts your regular lens or replaces it so you can move in extremely close.

At close focusing distances even a slight change in camera position makes a big change in the image. The camera supports shown on p. 145 help you compose a close-up picture exactly, and help keep the camera steady during longer-than-normal close-up exposures.

Close-up lenses that attach to the front of a camera lens are available from Canon in two strengths. The Close-up 240 lets you focus as close as 240mm (9.5 in) to the subject when your camera is set to the infinity mark. With the Close-up 450 you can focus as close as 450mm (18 in). The closer you are to the subject the more it will be magnified, so the Close-up 240 is the stronger of the two attachments. Each close-up lens is available in 58mm, 55mm, and 48mm sizes to fit various lens diameters. They are named with their diameter followed by their strength: a Canon 58 Close-up 450 will fit a camera lens that is 58mm in diameter and will focus as close as 450mm from the subject (when the camera lens is set at infinity).

Macro lenses are for close-up work. The 20mm f/3.5 Macro Lens is designed for bellows mounting and magnifies from 4X to 10X life size. Canon also makes (not shown) a 35mm f/2.8 Macro Lens for magnifications (with a bellows) from 1.8X to 5X life size.

Two Canon lenses are usable either as regular camera lenses or for close-ups. A 50mm f/3.5 Macro Lens provides 0.5X magnification without any accessories or 1X magnification with the addition of an extension tube. A 100mm f/4 Macro Lens produces magnifications similar to the 50mm lens but at a greater working distance from the subject.

 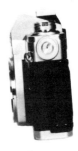

Extension tubes *that fit singly or in combination between the camera and lens are made in various lengths. The Extension Tube M Set (shown here) consists of a 5mm, a 10mm, and two 20mm tubes. If all four tubes are attached between a 55mm camera lens and the camera, the image of the subject on the film will be life size (1:1). Both exposure metering and aperture adjustment with these tubes are manual: you stop down the lens to take a light reading and when you are ready to make an exposure.*

Extension Tubes FL15 and FL25 (15mm and 25mm in length) automatically stop down the lens at the moment of exposure but they still require that you manually stop down the lens to take a light reading.

Vari-Extension Tubes can be set to variable lengths: the M15–25 adjusts from 15–25mm, the M30–55 from 30–55mm.

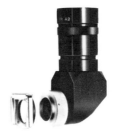

*A **magnifier** attaches to the viewfinder eyepiece and magnifies the center of the field of view 2.5X, which aids precision focusing in close-up photography, copying, and wide-angle photography. Only the center of the image is visible with the magnifier in place; the unit raises on its hinges for viewing the whole field of view. Magnifier R fits the F-1 camera, Magnifier S fits other models.*

*An **angle finder** makes it easier to view a scene from a low camera angle. The unit attaches to the viewfinder and can be rotated to the best angle for viewing. The Angle Finder A2 shows the image upright but reversed from right to left. The Angle Finder B incorporates a pentaprism to produce a corrected image for viewing.*

Canon Close-up Equipment (cont.)

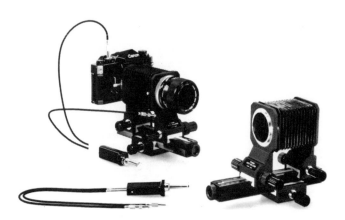

Bellows *units fit between the lens and the camera body. This Auto Bellows has individually adjustable controls so you can move either lens or camera or both together. A double cable release system provides auto-matic diaphragm operation with FD and FL lenses: one end of the release threads into a socket on the front plate of the bellows and the other attaches to the camera's shutter release; depressing the cable release automatically stops down the lens.*

The bellows provides an extension between camera and lens of from 39mm to 175mm (1.5–6.9 in). Scales on the bellows support rail show the magnification at various extensions of the bellows when a 50mm lens is mounted either conventionally or in reversed position. Accessories are available for copying 35mm slides or film and 16mm or 8mm film.

Macrophoto Coupler FL. At close focusing distances all lenses made for general photography (and even macro lenses at very close distances) will function better if reversed so that the rear element of the lens faces the subject. The Macrophoto Coupler FL attaches between the camera and lens to let you do this. The coupler is available in 48mm, 55mm, and 58mm sizes to fit lenses of these diameters.

Copy Stand 4 can be used with any single-lens reflex camera and is shown here with a movie camera. The camera attaches to a movable carrying arm that locks in place in any position on the 617mm (24 5/16 in) upright stanchion. The baseboard (450 × 420mm, 17 11/16 × 16 1/2 in) provides a sturdy support. The stand is useful for close-up photography, copy work, and as a stable support for the camera in certain setups with a microscope.

The Photomicro Unit F (not shown) connects the camera body to any microscope with a 24mm outside diameter sleeve. The unit consists of an outer and an inner hood tube, a light-shielding tube for the eyepiece sleeve, and a clamp ring for mounting. The unit creates a fixed distance (108.4mm, 4 5/16 in) between the microscope eyepiece and the film and produces on film about 1/2 the microscope's magnification.

Handy Stand F is a convenient camera support for tabletop copy work. The stand is small and lightweight and can be disassembled for storage. Marks on the legs make it easy to line them up evenly. The stand consists of legs, pedestal, a ring that attaches the lens to the stand, plus one Extension Tube M5.

The Microphoto Hood (not shown) is also used for microscope work. It attaches to the microscope and a bellows unit attaches to it (by means of a lens mount Converter A). The hood and bellows are supported by the Copy Stand vertically over the microscope. This combination provides variable distances between the microscope eyepiece and the film and produces on the film about 0.5X to 1X the microscope's magnification.

Depth of Field in a Close-up

The closer you focus on a scene, the less of that scene will be sharp in the final photograph. The depth of field—the distance between the nearest and farthest points that are acceptably sharp—may only be an inch or so at close focusing distances. Areas that are farther from or closer to the camera will be out of focus (see below).

If you want more depth of field you can shoot at a smaller aperture, but if you do so you may have to use a camera support to prevent camera motion since the exposure time lengthens as you decrease the size of the aperture.

Shallow depth of field can often be used to advantage. It can make a sharply focused subject stand out against an out-of-focus background. A sharp and detailed background that is not directly related to the subject can be a distraction and having it out of focus is one way to make it less prominent.

Depth of field is easily seen in the photograph at right. The nuts closest to the camera are definitely out of focus. They gradually become sharper as they approach the plane of critical focus—the point that was focused on. The

Depth-of-Field

Farthest sharp area

Plane of critical focus

Nearest sharp area

nuts become out of focus again as they move farther from the camera. At close focusing distances, the depth of field extends about half way in front of and half way behind the plane of critical focus.

Barbara Alper

Barbara M. Marshall

Left: because depth of field is so shallow in a close-up, it is easy to make a distracting background less conspicuous by having it out of focus. Below: the photographer focused on the top of the onion. The bottom of the onion is far enough away to be out of focus. In close-up photography it is vital to focus carefully on the most important part of a scene.

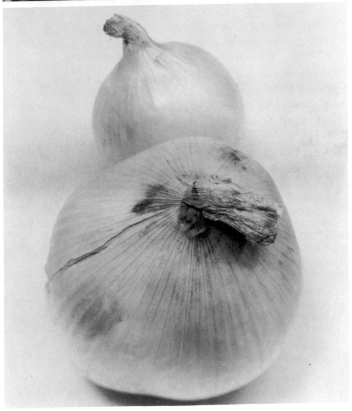

Eric Myrvaagnes

Close-up Exposures

Metering close-up subjects is basically similar to metering other subjects: the exposure recommended by the camera works well in average scenes (see pp. 44–45 for more about metering basics). The camera measures the brightness of the scene visible in the viewfinder, so that accurate metering of even very small objects is relatively easy in a close-up because the image is often enlarged enough to fill most of the viewfinder.

Metering is also simplified because the meter reads only the brightness of the light that actually reaches the film. Close-up equipment like extension tubes and bellows, as well as macro lenses at their farthest extensions, increase the distance between the lens and the film. The farther that light travels between lens and film, the dimmer the light that strikes the film and the more that the exposure must be increased. The meter takes this into account when it calculates an exposure.

If close-up accessories like extension tubes and bellows that come between the lens and camera are not specifically designed to integrate with the automatic system, they will interrupt the automatic functioning of the camera. If this happens the camera's meter will still work, but you will have to set the camera's aperture and/or shutter speed manually. See manufacturer's literature.

For an accurate reading of an extremely small subject, you can make a substitution reading from a gray card, a card of middle gray manufactured for photographic purposes and available in camera stores. Place the card in the same light as the subject, meter the brightness of the card, and set the exposure manually.

Jerry Howard

The exposure recommended by your camera's meter works well when the subject is more or less the same tone as the background or when it is large enough to fill most of the viewfinder (above). If your subject is much lighter or darker than its background (below), you can use exposure compensation to increase or decrease the normal exposure (see pp. 46–49).

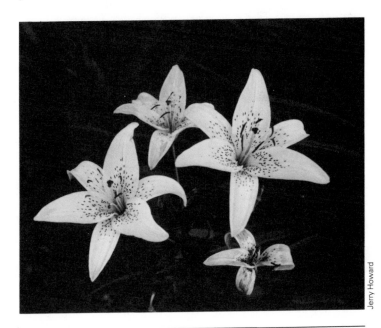

Jerry Howard

Still Lifes

Still-life photography generally involves the use of commonplace objects. The photographer sees a texture, shape, color, or pattern of highlight and shadow and captures it on film. The secret to getting good still lifes is *seeing* them, and many possibilities exist ready made if you develop the habit of looking for them. You will want to preview the way the final photograph will look and you can do that best through the viewfinder. Try looking through your viewfinder at various objects around you. Try moving in close enough to isolate them from other objects nearby. Or you can arrange objects yourself; place your camera on a tripod and look at the scene several times through the viewfinder as you arrange and rearrange objects in it.

A ready-made still life: everything was there just as the photograph shows it—old wedding picture, neatly pressed linen cover, light shining softly through the window. It evokes an image of an orderly and slightly old fashioned home.

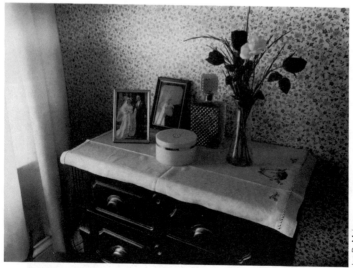

Joe DeMaio

Barbara M. Marshall

Ordinary vegetables have an endless variety of shapes and textures. Above: sidelighting on three heads of lettuce highlights their crinkled leaves (see lighting textured objects, pp. 152–153). The eye is also drawn to the three round shapes of their cores, which connect in a triangular shape that gives an inner solidity to the photograph. Below: white onions glow brightly against a dark background. A very dark background may cause your automatic exposure system to overexpose a light-toned subject. (See pp. 46–47.)

Eric Myrvaagnes

Photographing Textured Objects

To emphasize the texture and surface detail of a coin, shell, or other three-dimensional object, position it so that light rakes across its surface at a low angle and produces shadows that are visible from camera position. It is actually the shadows that make an object's ridges, ripples, and wrinkles apparent. The fewest shadows will be visible when light is coming from close to the camera's lens. More shadows will be visible and texture will be more noticeable when light comes from one side or behind the subject (see opposite). Compared to front lighting, side- or backlighting also increases the impression of volume in an object (see below). After the main or strongest light is in place, you might want to lighten the shadows slightly by adding fill light (see pp. 136–137), not to remove the shadows entirely, but to lighten them a bit so they don't appear excessively dark in the final photograph.

The tiny bumps on a sea anemone are brought into sharp relief by light coming from one side. The lighting also emphasized the round volume of the object.

Sam Laundon

Flint Born

*The direction that light is coming from relative to camera position deter-
mines how much texture will be visible in a photograph of a textured
object. Light that comes from camera position produces the fewest shad-
ows visible in the image and so the least apparent texture (top). Sidelight-
ing or backlighting emphasizes textures because it produces shadows
that are visible from camera position (center and bottom).*

Photographing Translucent Objects

Since translucent objects such as decorative glassware and stained glass windows allow light to pass through them, a natural way to photograph them is with light coming from behind. The glowing translucent quality of the subject is enhanced by backlighting, and colored glassware is often displayed in windows for just this purpose. In addition, backlighting eliminates the distracting reflections that are likely to occur when shiny glass is lit from the front. If you are using color film, choose one that matches the source of illumination: daylight film for objects lit by window light, tungsten film for objects illuminated by light bulbs.

If a stained glass window or a piece of glassware fills most of the viewfinder image, use the exposure recommended by the camera's automatic system. But if other very dark or very light areas occupy a large part of the scene, you may want to adjust the exposure. If, for example, a stained glass window is only a small part of the image and is surrounded by dark areas—not an uncommon situation when photographing a stained glass window in a large church—the camera will be influenced by the surrounding darkness and will tend to overexpose the window so it is too light. Use exposure compensation to decrease the exposure 1 or 2 stops. If brilliantly sunlit areas are visible behind glassware in a window, the camera may be overly influenced by the bright light outdoors, underexpose the glassware and make it too dark. Use exposure compensation to increase the exposure about 1 stop unless you want the objects to be silhouetted (see opposite bottom).

In any case, you might try bracketing your basic exposure by making an additional one with 1–2 stops more exposure, and a third exposure with 1–2 stops less. You can choose the best overall exposure after seeing the developed film.

Linda White

Above: light shining through a translucent object not only illuminates the object itself, but can create interesting patterns of light and shadow. Below: bottles in a window are silhouetted against a very bright background. When you want to see details in glassware that is against a very bright background, use exposure compensation to increase the exposure 1–2 stops. To draw attention away from objects outside the window, use a large lens aperture to put the background out of focus.

Bobbi Carrey

Photographing Flat Objects

When copying old photographs or shooting any flat subject (like a postage stamp or drawing), you'll want to provide full, even illumination of the subject without reflections or distracting textures and shadows. The best source of illumination consists of two lamps of equal intensity, arranged as shown opposite. A copy stand like the one shown on p. 145 makes the job easier but isn't essential.

Depth of field is very shallow at close focusing distances (see p. 68); you'll need to align the back of the camera parallel to the object or the focus may not be evenly sharp overall. Keeping the camera parallel also prevents distortion of the object; if the camera is not parallel, the part of the subject that is closer to the camera will be bigger in the image. This is particularly evident in rectangular objects, which "keystone" or take on a wedge shape (see below).

If you are copying an old photograph or other black-and-white object onto a black-and-white film, you can sometimes improve the image by filtering to lighten stains. Use a filter the same color as the stain: a yellow filter for a yellowish stain, blue filter for a bluish stain, and so on. Use a slow to medium speed film; the contrast and rendition of detail will be better than with very fast films.

Susan Lapides

If the camera back is not aligned parallel to the object you are photographing, you may get uneven focus as well as "keystoning," an enlargement of the part of the object closest to the camera. In this copy of a painting, the camera was tilted up a little; the bottom of the painting was closer to the camera than the top and therefore was larger. A carpenter's (spirit) level can be placed on top of the camera to make sure the camera is level and not tilted.

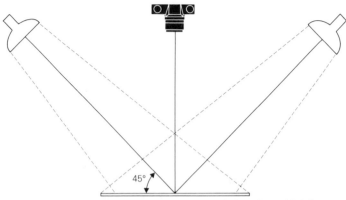

For even illumination of a flat object, place two lights of equal brightness, one on each side of the object, at about a 45° angle to it. Two 500-watt photoflood bulbs in reflectors are efficient light sources. Don't place the lights too close to the camera or you are likely to get reflections off the surface of the object, especially if it is at all glossy. Nor should you place them at too shallow an angle to the surface or you may make texture or surface unevenness visible.

Below: a copy of a photograph taken around the turn of the century. Yellowish stains on the original were made less conspicuous by photographing through a light yellow filter.

Useful Terms

Prepared by Lista Duren

angle of view The amount of a scene that can be recorded by a particular lens; determined by the focal length of the lens.

aperture The lens opening formed by the iris diaphragm inside the lens. The size is variable and is controlled by the aperture ring on the lens.

aperture-priority mode An automatic exposure system in which the photographer sets the aperture (f-stop) and the camera selects a shutter speed for correct exposure.

ASA A number rating that indicates the speed of a film. Stands for American Standards Association. See also **film speed.**

automatic exposure A mode of camera operation in which the camera automatically adjusts the aperture, shutter speed, or both for proper exposure.

automatic flash An electronic flash unit with a light-sensitive cell that determines the length of the flash for proper exposure by measuring the light reflected back from the subject.

bounce light Indirect light produced by pointing the light source away from the subject and using a ceiling or other surface to reflect the light back toward the subject. Softer and less harsh than direct light.

bracketing Taking several photographs of the same scene at different exposure settings, some greater than and some less than your first exposure, to ensure a well-exposed photograph.

color balance The overall accuracy with which the colors in a color photograph match or are capable of matching those in the original scene. Color films are balanced for use with specific light sources.

contrast The difference in brightness between the light and the dark parts of a scene or photograph.

contrasty Having greater-than-normal differences between light and dark areas.

cool Toward the green-blue-violet end of the visible spectrum.

daylight film Color film that has been balanced to produce natural-looking color when exposed in daylight. Images will look reddish if daylight film is used with tungsten light.

depth of field The distance between the nearest and farthest points that appear in acceptably sharp focus in a photograph. Depth of field varies with lens aperture, focal length, and camera-to-subject distance.

diffused light Light that has been scattered by reflection or by passing through a translucent material. Produces an even, often shadowless, light.

DIN A number rating used in Europe that indicates the speed of a film. Stands for Deutsche Industrie Norm. See also **film speed.**

direct light Light shining directly on the subject and producing strong highlights and deep shadows.

electronic flash (strobe) A camera accessory that provides a brilliant flash of light. A battery-powered unit requires occasional recharging or battery replacement, but unlike a flashbulb can be used repeatedly.

exposure 1. The act of allowing light to strike a light-sensitive surface. 2. The amount of light reaching the film, controlled by the combination of aperture and shutter speed.

exposure meter (light meter) A device built into all automatic cameras that measures the brightness of light.

exposure mode The type of camera operation (such as manual, shutter-priority, aperture-priority) that determines which controls you set and which ones the camera sets automatically. Some cameras operate in only one mode. Others may be used in a variety of modes.

film speed The relative sensitivity to light of photographic film. Measured by ASA, DIN, or ISO rating. Faster film (higher number) is more sensitive to light and requires less exposure than does slower film.

filter A piece of colored glass or plastic placed in front of the camera lens to alter the quality of the light reaching the film.

fisheye lens An extreme wide-angle lens covering a 180° angle of view. Straight lines appear curved at the edge of the photograph, and the image itself may be circular.

flare Stray light that reflects between the lens surfaces and results in a loss of contrast or an overall grayness in the final image.

flat Having less-than-normal differences between light and dark areas.

focal length The distance from the optical center of the lens to the film plane when the lens is focused on infinity. The focal length is usually expressed in millimeters (mm) and determines the angle of view (how much of the scene can be included in the picture) and the size of objects in the image. The longer the focal length, the narrower the angle of view and the more that objects are magnified.

focal plane See **film plane.**

frame 1. A single image in a roll of film. 2. The edges of an image.

f-stop (f-number) A numerical designation (f/2, f/2.8, etc.) indicating the size of the aperture (lens opening).

ghosting 1. Bright spots in the picture the same shape as the aperture (lens opening) caused by reflections between lens surfaces. 2. A blurred image combined with a sharp image in a flash picture. Can occur when a moving subject in bright light is photographed at a slow shutter speed with flash.

guide number A number on a flash unit that can be used to calculate the correct aperture for a particular film speed and flash-to-subject distance.

hand hold To support the camera with the hands rather than with a tripod or other fixed support.

hot shoe A clip on the top of the camera that attaches a flash unit and provides an electrical link to synchronize the flash with the camera shutter.

ISO A number rating that combines the ASA and DIN film speed ratings. Stands for International Standards Organization. See also **film speed.**

lens hood (lens shade) A shield that fits around the lens to prevent extraneous light from entering the lens and causing ghosting or flare.

light meter See **exposure meter.**

long-focal-length lens (telephoto lens) A lens that provides a narrow angle of view of a scene, including less of a scene than a lens of normal focal length and therefore magnifying objects in the image.

manual exposure A nonautomatic mode of camera operation in which the photographer sets both the aperture and the shutter speed.

negative 1. An image with colors or dark and light tones that are the opposite of those in the original scene. 2. Film that was exposed in the camera and processed to form a negative image.

normal-focal-length lens (standard lens) A lens that provides about the same angle of view of a scene as the human eye and that does not seem to magnify or diminish the size of objects in the image unduly.

open up To increase the size of the lens aperture. The opposite of stop down.

overexposure Exposing the film to more light than is needed to render the scene as the eye sees it. Results in a too dark (dense) negative or a too light positive.

pan To move the camera during the exposure in the same direction as a moving subject. The effect is that the subject stays relatively sharp and the background becomes blurred.

positive An image with colors or light and dark tones that are similar to those in the original scene.

print An image (usually a positive one) on photographic paper, made from a negative or a transparency.

reciprocity effect (reciprocity failure) A shift in the color balance or the darkness of an image caused by very long or very short exposures.

reversal film Photographic film that produces a positive image (a transparency) upon exposure and development.

short-focal-length lens (wide-angle lens) A lens that provides a wide angle of view of a scene, including more of the subject area than does a lens of normal focal length.

shutter The device in the camera that opens and closes to expose the film to light for a measured length of time.

shutter-priority mode An automatic exposure system in which the photographer sets the shutter speed and the camera selects the aperture (f-stop) for correct exposure.

shutter speed dial The camera control that selects the length of time the film is exposed to light.

silhouette A dark shape with little or no detail appearing against a light background.

single-lens reflex (SLR) A type of camera with one lens which is used both for viewing and for taking the picture.

slide A positive image on a clear film base viewed by passing light through from behind with a projector or light box. Usually in color.

SLR See **single-lens reflex.**

standard lens See **normal-focal-length lens.**

stop 1. An aperture setting that indicates the size of the lens opening. 2. A change in exposure by a factor of two. Changing the aperture from one setting to the next doubles or halves the amount of light reaching the film. Changing the shutter speed from one setting to the next does the same thing. Either changes the exposure one stop.

stop down To decrease the size of the lens aperture. The opposite of open up.

strobe See **electronic flash.**

synchronize To cause a flash unit to fire while the camera shutter is open.

telephoto lens See **long-focal-length lens.**

35mm The width of the film used in the cameras described in this book.

transparency See **slide.**

tripod A three-legged support for the camera.

tungsten film Color film that has been balanced to produce natural-looking color when exposed in tungsten light. Images will look bluish if tungsten film is used in daylight.

underexposure Exposing the film to less light than is needed to render the scene as the eye sees it. Results in a too light (thin) negative or a too dark positive.

vignette To shade the edges of an image so they are underexposed and dark. A lens hood that is too long for the lens will cut into the angle of view and cause vignetting.

warm Toward the red-orange-yellow end of the visible spectrum.

wide-angle lens See **short-focal-length lens.**

Index

Prepared by Lisbeth Murray

Other Curtin & London Books: Automatic Camera Series

Photographing Indoors by Barbara London and Richard Boyer. 144 pages. Paperback $6.95.

Many of your best photographic opportunities are indoors using flash or available light. This book covers everything you need to know about using your automatic camera and automatic flash indoors, at home, or when traveling.

Contents
- Basics of automatic photography indoors
- Lighting
- Flash
- People
- Sports and recreation
- Close-ups and still lifes
- A photo story
- Preserving and displaying your pictures

Photographing Outdoors by Barbara London and Richard Boyer. 144 pages. Paperback $6.95.

This book clearly and visually explains how to use your automatic 35mm SLR out of doors. It tells you how to photograph in good and bad weather, how to photograph nature, landscapes, people, and sports.

Contents
- Basics of automatic photography outdoors
- Light and weather
- Landscapes
- Nature
- People
- Pictures at night
- Sports and recreation

Getting the Most from Your 35mm SLR

What Are You Doing Wrong* With Your Automatic Camera

*and how to do it right

What Are You Doing Wrong by Dennis P. Curtin and Barbara London. 144 pages. Paperback $6.95.

Organized to guide you in learning photography as you photograph, this book explains how you may have made over 60 common mistakes, how to avoid them, or, even more important, how to use these "mistakes" as creative techniques in other situations.

Contents
- Evaluating your choices
- Color
- Camera handling
- Exposure
- Sharpness
- Flash
- Miscellaneous problems
- Preventing problems
- Improving good pictures

Other Curtin & London Books: Into Your Darkroom Step by Step

Into Your Darkroom Step by Step by Dennis P. Curtin
with Steve Musselman
Number of pages: 96
Number of illustrations: 350
Trim size: 8½ × 11
Spiral bound: $11.95

Thousands of photographers every year discover that no one can process their film and make their prints as well and as inexpensively as they can themselves. It's simple to learn if you have a good teacher, and the excitement of watching your images appear in the developing tray is something you never get over no matter how long you make prints. This book is probably the most sensible book available to get you started and build a good foundation in the basics of darkroom techniques. Here, in an easy-to-follow, step by step format, is what you need to know to begin working in your darkroom.

Contents

Getting ready in 3 steps
Equipment you'll need
Setting up your darkroom
Mixing chemicals

Developing negatives in 3 steps
Getting ready
Loading your film onto reels
Processing your negatives

Making proof sheets in 3 steps
Getting ready
The test strip
The final proof sheet

Making enlarged prints in 3 steps
Getting ready
The test strip
The final print

Making better prints in 4 steps
Getting ready
Printing controls
Print finishing
Troubleshooting

A few ideas from the book

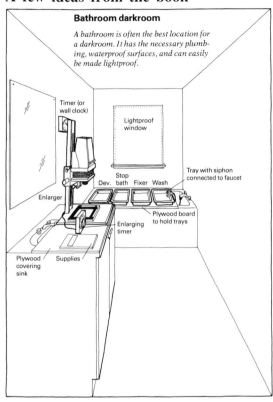

Bathroom darkroom

A bathroom is often the best location for a darkroom. It has the necessary plumbing, waterproof surfaces, and can easily be made lightproof.

Timer (or wall clock)

Lightproof window

Tray with siphon connected to faucet

Stop
Dev. bath Fixer Wash

Enlarger

Plywood board to hold trays

Enlarging timer

Plywood covering sink

Supplies

Loading your film onto reels

1. Holding the loose film Trim the end of the film square. Point the film towards the reel, with the film unwinding from the top. Bow the film by squeezing it lightly by the edges.

2. Hold the reel With your other hand, feel for the outer end of the reel's spiral with the tip of your forefinger. Position the reel with the end of the spiral on top. Point the spiral in the same direction your forefinger is pointing.

rotate

3. Attaching the film to the reel Guide the end of the film into the center of the reel. Make sure the film feeds in straight and sits squarely in the center. Attach the film to the clip or pin (if any) in the center.

4. Winding the film Hold the film slightly bowed and rotate the reel in the direction shown. Allow the film to be drawn through your fingers and onto the reel.